forgotten
TALES
of
New Mexico

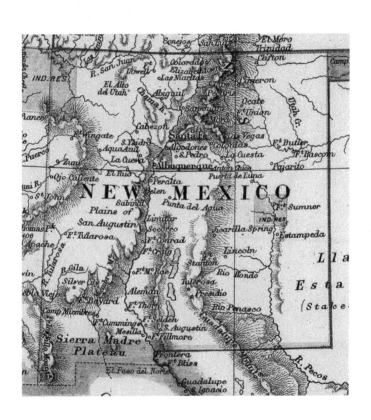

forgotten TALES of New Mexico

Ellen Dornan

Charleston London

THE
History
PRESS

Published by The History Press
Charleston, SC 29403
www.historypress.net

First published 2012

Manufactured in the United States

ISBN 978.1.60949.485.8

Library of Congress Cataloging-in-Publication Data

Dornan, Ellen.
Forgotten tales of New Mexico / Ellen Dornan.
p. cm.
ISBN 978-1-60949-485-8
1. New Mexico--History--Anecdotes. 2. New Mexico--Biography--
Anecdotes. 3. New Mexico--Social life and customs--Anecdotes. I. Title.
F796.6.D67 2012
978.9--dc23
2011049605

Contents

CONTENTS

Preface

For as long as I can remember, I have loved the oddities of history. As a child, I seemed to have a limitless capacity for trivia about Napoleon spritzing perfume on his horse or Cleopatra eating onions. As I grew older, I found I also enjoyed puzzling out historical ambiguities, where different parties had radically different interpretations of the same events. How lucky I was to find a home in New Mexico!

New Mexico's history is full of bumbling misadventures, stubborn misunderstandings, rebellious yet upright citizens, conniving politicians and mystical visionaries. Far from being cartoonish caricatures, the central (and secondary) figures of New Mexico carry deeper layers of meaning, in part due to the varied perspectives that inform each event. Were certain historical women healers or witches? Was it patriotic or foolish to resist the Americans? Are the Texans more fearsome or are

the French? Depending on who answers, you will find an affirmative for each query.

New Mexico itself has been a fluid idea over the centuries. New Mexico has been a kingdom, a province, a department, a U.S. territory, a Confederate territory and a state. New Mexico has been a northern frontier and a southern border. Depending on the cartographer, New Mexico has encompassed the Arctic, the Pacific Coast, Kansas, Colorado and Arizona. No matter how big it got in theory, permanent settlement was concentrated for centuries in a fairly small area.

This collection includes stories I have read and relished over years of studying and interpreting New Mexico and western history. Each story surprised and delighted me when I first learned it, but in the course of researching this book, I was once again surprised by how hotly contested every New Mexico story is and how complex each story becomes when more than one perspective is taken into account.

Some of these stories have been forgotten because they were transmitted orally. Some stories were not so much forgotten as classified until the end of the Cold War. Others are dismissed by many for being apocryphal but still find plenty of faithful adherents. Still others came to light by combing through old marriage records and the records of the Inquisition, a rich source for early gossip.

There are some Navajo and Spanish words used in this book, so if there is an italicized word you don't understand, please refer to the glossary at the end of the book.

I hope I have done the stories, the people and the places in New Mexico justice with this collection. I offer many thanks to the amazing ninja librarians at UNM's Center for Southwest Research for their endless patience and enthusiasm for historical research. Thanks also to my late teacher, Helen Wagner, who failed me in sixth-grade English and then made me promise to dedicate my first book to her.

Part I

DOMESTIC STRIFE

MURDER OF MARÍA MARTÍN BARBA

The short and tragic life of María Martín offers a glimpse of how dangerous life could be for the women among Don Juan de Oñate's colonists. María Martín Serrano was born about 1580 in the mining town of Zacatecas, Mexico. Typically for that time, her parents married her off at the age of twelve, to a distant relative named Alonso Martín Barba. When she was sixteen years old, her husband and father both made the choice to move to New Mexico. The teenager made the long and dangerous journey with her husband and two young daughters. Her father and brothers moved to Santa Cruz at first and then parted ways. Her father made a home in the new *presidio* of Santa Fe, where he fathered a mixed-blood son. Her brother established an *estancia* on the road to Picuris.

Instead of staying in Santa Cruz, or even the defensive outpost of Santa Fe, with the majority of the colonists, Alonso moved his young wife and their small children near the pueblo of Chílílí, perhaps encouraged by the government to help protect the frontier. Even today, Chílílí feels like the middle of nowhere, but in 1607, when María was preparing her daughters' weddings, it must have felt like the end of the earth. Slowly, the family settled in and built up a small farm. After a few years, missions were established in the area, which must have been a comfort to María; when her third daughter married, she would have been able to marry in the Chílílí mission church.

Even with the mission, María's life must have been isolated. She shared neither a language nor a culture with the Pueblo women, and the duties of a farm wife would have kept her close to their *rancho*. There is some evidence that the Martín Barbas, like many New Mexican colonists in the early days, had some Native American slaves, but even so, she was not free to travel.

As a man, Alonso Martín Barba did have the freedom to travel—and wander he did, right into the arms of María Bernal, the daughter of Greek immigrant José Griegos. María Bernal was probably the wife of Juan Duran de la Cruz, a "somewhat swarthy, beardless and tall" rancher. Señor Duran de la Cruz must have been out with his animals too much because the affair got hot enough that María Bernal decided to do away with the other María, her lover's wife.

The details of how it happened are lost to history, but we do know that Alonso's mistress María successfully killed his wife María by poisoning her around 1610. Whether Alonso had a hand in the murder is debatable. Rather than getting his wife out of his way so he could marry his mistress, Alonso did not marry María Bernal when his wife died. Instead, within the year, he married a twenty-four-year-old woman named Francisca de Herrera Abrego, and they had five children together. Perhaps he washed his hands of his murderous mistress, but he also didn't press charges against her.

Oddly enough, María Martín's family did not try to avenge her death, either. In fact, her half brother,

Hernán, ended up marrying the widow María Catalina (Griegos) Bernal, almost certainly the same woman, and had two children by her. They maintained a home in Santa Fe but also seem to have lived not far south of the Martín Barbas, clearly maintaining family ties. Hernán does not seem to have stayed married to her long because the marriage records note that Hernán Martín Serrano married María de Madrid shortly after the birth of his second child with María Bernal. Perhaps María died from complications in childbirth, leaving Hernán with the babies.

Drought, pestilence and famine struck the region, and many died. The nearby pueblos were all but abandoned, with some people moving down to the El Paso del Norte area and some moving to Isleta. The colonists continued to persecute and mistreat traditional native leaders, who finally revolted against the Spanish, driving them from New Mexico to El Paso and keeping them at bay for over a decade. Many of the settlers in far-flung areas like the Galisteo Basin or the Salinas were warned in advance, and those who did not heed the warning and leave New Mexico were cut down where they stood.

Alonso Martín Barba, already middle aged at the time of his wife's murder, did not survive to see the abandonment or the Pueblo Revolt in 1680, although his children and some of his servants did, as did his second wife, Francisca. She was counted in a 1684 census in El Paso as the head of a household with five children, surely her grandchildren.

María's brother Hernán also escaped New Mexico after the Pueblo Revolt, with yet another wife, Josefa de la Ascensción Gonzales.

GOVERNOR MANSO'S PROBLEM CHILD

Fray Tomás Manso gained enough power running New Mexico's mission supply service as *procurador* to put his twenty-seven-year-old little brother in the governor's office. Juan Manso was very different from his saintly brother, who went on to achieve a bishopric in Central America. While the church fathers appreciated Juan Manso's support for the church's authority—a rarity in the ongoing seventeenth-century war between the clergy and the secular government—they found little to forgive in his personal life.

Governor Manso loved the alluring Doña Margarita Marquez, and they cared very little that she already had a husband, Captain Geronimo de Carvajal. Manso had showered Carvajal with honor, giving him the *encomendero* for the Hopi pueblo of Awatobi, far west of the gubernatorial love nest. Manso had learned enough scripture to be familiar with the story of David and Uriah the Hittite and sent the poor captain again and again to the western frontier to protect his *encomienda* from the hostile and unconverted natives that threatened the tiny colony from that direction. While Carvajal was valiantly defending Christendom, the governor could easily ride

every day from Santa Fe to his lover's *estancia* in Nuestra Señora de los Remedios de los Cerrillos.

Inevitably, Doña Margarita became pregnant and bore a daughter. All the gossips swiftly counted on their fingers and figured out that the girl was the governor's child. Despite this common knowledge, the powerful *procurador* and his equally influential brother pressured the local priest to baptize the baby as Carvajal's. Governor Manso brazenly stood as *compadre*, or godfather, to the girl and continued his blithe visits to Los Cerillos. But when Doña Margarita bore a son in 1656, Juan Manso could not bear to have the hapless Captain Carvajal raise him. As soon as the deceived husband rode out of town to defend his frontier *encomienda*, his faithless wife staged a mock funeral for the child. Accounts differ, but she apparently stuffed a coffin with a doll or some rags and made Father Sacristan officiate a funeral and bury the empty coffin.

The child himself was spirited out of New Mexico. Some New Mexicans claimed that the wife of a prominent citizen carried the baby down the long, dusty Camino Real to be raised as the governor's son somewhere in the southern province of Nueva Viscaya. Bernardo López de Mendizábal, the governor who succeeded Manso, brought several complaints against him and echoed the popular belief that the rancher Luís Martín Serrano had a hand in concealing the baby and smuggling him down into New Spain.

No one knows for certain what happened to the "disappeared" son of Juan Manso, but the path probably led to Hidalgo de Parral, a prosperous silver mining town that was then the closest trade center to New Mexico. Fray Tomás Manso had built up powerful trade relations there, both as the wielder of the largest wallet in New Mexico, the mission supply grant from the king himself, and as the official transporter of the valuable mercury shipments from the Royal Treasury to the northern mines. Without mercury, the rich mines of Zacatecas and Parral would produce no silver, and chronic shortages of imported Spanish mercury meant that the man who controlled the mercury trade could wield considerable influence if he chose.

Perhaps because of this influence, a baffling entry appears in the church records of Hidalgo de Parral, dated April 12, 1657. Francisca de Arratia, claiming to be the widow of Hernán Martín Serrano of Santa Fe, baptized a baby boy. If this was true, there were two possible fathers. Hernán Martín Serrano the elder was born nearly a century before and was surely not fathering children in the summer of 1656. His handsome son, Captain Hernán Martín Serrano II and Luís's brother or half brother, was very much alive and married to someone else. That the child was not Hernán's is clear because Doña Francisca was no shamed farm girl with a *mestizo* baby. The godparents were from the most prominent silver mining family in Parral, one that had developed loyal ties to the powerful *procurador*.

When Governor Lopez succeeded Manso, he included complaints about this illicit liaison in the *residencia*, a kind of routine investigation one governor performed on the previous governor. The real scandal came when Father Sacristan, who had conducted the fake baptism and the fake burial under duress, eventually became overwhelmed with guilt and took his own life, leaving behind a detailed explanation of the events in which he had become embroiled. The scandal erupted after Fray Tomás left for his bishopric and could no longer protect his little brother. Manso dropped out of public life in shame.

Eventually, López offered Geronimo de Carvajal a sort of consolation prize, the office of *alcalde* mayor of the Galisteo district, which encompassed the pueblos and rich grasslands east of Carvajal's *estancia*. Carvajal must have been relieved to be done with the hardships of life on a hostile frontier, but his feelings about settling down with his unfaithful wife are harder to imagine. As for Manso, he tried to follow in his brother's footsteps as a trader and continued to do business in Parral as much as he could. As in love, he was too impetuous in business, and a series of poor business decisions ultimately resulted in his impoverishment and early demise.

TWO SISTERS FOR LUIS CONTRERAS

For a while, Eusebio Duran y Chaves must have thought his life was pretty much coming up roses. In 1774, when Chaves was forty-seven, the king agreed to Chaves's rather overblown petition to recognize his illustrious ancestry and appointed Eusebio the *alcalde mayor* of Albuquerque. If ceremonial honors weren't enough, his family's lands and livestock were multiplying quickly enough that the extended Duran y Chavez clan was well on its way to becoming the richest and most important family in the Rio Abajo, or lower New Mexico.

For Eusebio, the thorns on the rosebush of his life were his two willful daughters. Eusebio had six children altogether, but it was Maria Barbara del Carmen Chavez and Juana Catarina Duran y Chaves who gave him restless nights. It all started auspiciously: the older daughter, Maria Barbara (who went by the name of Barbara), did what she was supposed to do and married the respectable notary, José Manuel Aragon, in 1781 at a ceremony at Sandia Pueblo Mission. José served as notary both for the Sandia mission and the Alameda church. Together, the couple had several children, but at some point after child number eight, Aragon died.

Within the decade, the widow Barbara was carrying on a torrid affair with a twenty-four-year-old man from El Paso by the name of José Luis Contreras. Although this was potentially scandalous, it was not unheard of. Couples often

did not marry before cohabitating or sleeping together, since a wedding often cost more than a family could afford, and not all communities had priests. Of course, a priest was just down the road in Albuquerque, and there is little doubt that the wealthy *alcalde mayor* could easily afford the priest's fee for the wedding.

At any rate, the relationship might have passed without comment in the history books, but Barbara and Luis's union resulted in a baby. Even that might not have mattered to anyone but the baby, except that not long after Barbara and Luis knew about their forthcoming bundle of joy, Barbara's little sister, Juana, tearfully admitted that she was also pregnant out of wedlock. Like many women at that time who enjoyed premarital amusements and found themselves pregnant, she insisted that the father of her baby had promised marriage. She told her father that she would agree to marry the man who had taken her virtue—none other than Luis Contreras, father of Barbara's baby.

Eusebio must have been fit to be tied, and the response from the priest could only have made him angrier. According to the strict marriage laws of New Mexico, a set of conditions called dire impediments prohibited marriage, including something called affinity, which prevents close family members from marrying. Couples with dire impediments could marry, but they required Episcopal or papal dispensation to do so. Unfortunately, the marital investigation, or *diligencia*, in October 1796 revealed a "second degree affinity through illicit copula,"

which definitely counted as a dire impediment. The *alcalde mayor* reluctantly called in the Holy Office of the Inquisition, which wrote to the bishop in Durango pleading for dispensation. Long after both Barbara's and Juana's children were born, the answer came back: José Luis Contreras was to marry the younger Juana, but only after both performed public penance.

Nothing remains in the record about how Barbara felt about the judgment, but she must have been at least slightly relieved to escape both the public penance and marriage to two-timing Luis. She stayed in Corrales, and she and her nine children, all with the name of Aragon, were still living "happily ever after" when they took the census in 1818. Juana and Luis completed their penance, which was usually a kind of "walk of shame" while dressed in penitent robes, but left Alameda shortly thereafter. They moved to El Paso, where they were not the subject of all the wagging tongues in town, and married at Guadalupe del Paso on February 1, 1797.

JULIA'S HAUNTING MARRIAGE

Abraham Staab tried to provide his wife and children with all the worldly goods they could enjoy, but his wife's deep depression cast a permanent pall on their family, as well as on their mansion. Like many entrepreneurial New Mexicans during the territorial period, Abraham Staab

spent his early adulthood amassing a fortune as a supply contractor for the U.S. Army, particularly during the Civil War. Determined to give his wife and children the best in life, he constructed a three-story brick mansion, still a wonder in adobe-centric Santa Fe, and furnished it with the finest materials and furnishings, imported all the way from Europe on the recently established railroad.

Although he had escaped the ghettos of Germany in 1854 and arrived in New Mexico as a humble peddler, Staab had risen to prominence in Santa Fe and was active in political circles. He served as a government official and even shared some of the glory when President Rutherford Hayes visited in 1880. He helped found the Santa Fe Chamber of Commerce and served as one of its first presidents, as well as being a director of the First National Bank in Santa Fe, a commissioner, a bank director and more.

At first, Abraham's pretty wife, Julia, loved to show off her fabulous dwelling. Although Anglo, she soon became a lynchpin of Santa Fe high society by entertaining lavishly. Prominent New Mexicans, famous for their limitless appetite for dancing, flocked to many a fandango in her beautiful third-floor ballroom and were greeted by her butler, a black man named MacKine. Her six children lived mostly on the second floor, reached via a grand staircase with elegant polished wood banisters. How well they slept during the *bailes* is anyone's guess, but perhaps Julia was an indulgent mother and let them stay up late. Nor were the dances the only excesses: on mornings after Papa Staab

had been playing cards with his friends, each child found a twenty-dollar gold piece next to his or her breakfast plate.

Julia was the envy of the women in Santa Fe, but her life was less than perfect. Abraham was overbearing and "ruled with an iron fist," and Julia became withdrawn. When Julia bore her eighth child in 1883, all the happy times ended. Little Henriette died soon after birth, and Julia was prostrated by her sorrow. Some say her hair turned white overnight, but whether it was overnight or within a short time, it is true that her depression caused her hair to become prematurely white. She hosted no more *fandangos*, dinners or teas for the society ladies of Santa Fe. Her surviving children saw less and less of their once-doting mother.

Still grief-stricken from her loss, Julia could not refuse her husband and suffered through several unsuccessful pregnancies. She became increasingly withdrawn and ill. She traveled frequently to Germany to be in her sisters' care and possibly away from her controlling husband. During one visit, her depression overwhelmed her, and she suffered a "dreadful accident," which she tried to persuade the doctor to keep a secret.

Mad with grief, refusing to come out of her room at all, Julia Staab died on May 14, 1896, at fifty-two years. Rumor instantly swirled around her death. Those who knew her during the happy years blamed her husband, not just for her illness but also for her death. Many speculated that Abraham Staab had killed his once-lovely wife "so he could resume his powerful position and social standing in the

community." If that was indeed the case, it was unsuccessful. Although the Staab mansion was as elegant and luxurious as ever, the taint of madness and death dampened any inclination Santa Fe society had to darken its doors.

Abraham raised his surviving children as best as he could, but misfortune persisted in troubling the family. A fire burned the ballroom, a reminder of the early, happy days. Not too long afterward, Abraham died. The children eventually sold the mansion, put aside their unhappy memories and scattered to the winds. Abraham's children did not remember him fondly; in later years, his daughter described him as a "terrible tyrant" who "almost succeeded in wrecking the lives of three children."

The story should end there. But in 1932, the Staab Mansion became the now famous La Posada Hotel, and even today, it seems that Julia is around, alarming hotel guests and staff alike. Some report her ghostly presence gliding down the still-elegant staircase, and others suspect her of meddling when renovations are being done. While some "hauntings" happen in the public part of the hotel, like the night the bar glasses supposedly flew off their shelves at closing time, most occur in the room where Julia tragically ended her days. Hotel operators report calls coming through on the line from her bedroom, even when the phone is disconnected, and many have noticed sounds coming from behind the door.

Part II

POISONOUS POLITICS

PUEBLO GOVERNOR ESTÉBAN CLEMENTE

One of the most curious figures of the seventeenth century was Don Estéban Clemente, Indian governor of the Salinas Pueblos, east of the Manzano Mountains. Unlike most New Mexicans of the time, Spanish or native, Don Estéban was "muy racional" (meaning learned) and, thanks to the mission priests, could read, write and speak Spanish as well as six other languages. Don Estéban was in some ways the Spanish ideal of an acculturated Indian…until he mounted a revolt against the mission priests.

Don Estéban Clemente grew up in the mission pueblo of Abó and in adulthood exercised some form of leadership over the villages of the Salinas district. Besides being a reliable diplomat between the Spanish and the southern Pueblos, he was also a skilled trader. Apparently, Don Estéban was a skilled enough trader that he amassed enough head of livestock to run a caravan down to Parral.

He also made frequent visits to the Apaches of the Siete Ríos area as a trade representative. The people of Quarai, a mix of Tewa and Jumano, were not at peace with the Siete Ríos Apaches for most of the middle of the 1600s and could not venture out to hunt the buffalo themselves or to trade with the Plains Jumano as they had in years past. Don Estéban arranged for trade fairs on the neutral territory at the Las Humanas pueblo, now the National Park unit known as Gran Quivira. During periods of heightened

intertribal conflict, the people of Quarai were prohibited from visiting Las Humanas when the Apache tribes from the Seven Rivers area in the south were there.

Don Estéban also represented the pueblos in matters of trade and policy with the Spanish. The Spanish governor, López de Mendizábal, trusted Don Estéban enough to award him a contract for trading with the Siete Ríos Apaches for valuable buffalo and antelope hides and another to transport goods along El Camino Real. Governor López supplied him with goods to be exchanged with the Apaches during these expeditions. The governor also helped to organize trading parties to the Plains.

His whole life, Don Estéban had a good relationship with the church, particularly with the priest of Quarai, Fray Geronimo de la Llana. Decades after both men had died, a witness tells of Don Estéban visiting his parents and describing the priest at Quarai. Apparently, Don Estéban admired Fray Geronimo's ability to talk and laugh and his rectitude in sleeping on the floor with an adobe brick for his pillow.

Unfortunately, the good father died in 1659, leaving his parishioners to the not-so-tender mercies of Fray Nicolás de Freitas. Freitas wanted to crack down on the Pueblos and keep them from celebrating their traditional rituals and observances. Governor López had been very lenient toward dances and kachina ceremonies, just to aggravate the priests, and it was working. As soon as they got rid of López and got a more sympathetic governor, the priests

began to raid the Pueblos, burning everything they found that smacked of paganism and "idolatry."

After the sacred masks and fetishes were destroyed, a terrible drought cycle struck, and Don Estéban watched as the cattle sickened and died, and then the people. Clearly the priests were in the wrong, and if the priests were wrong, the Spanish were wrong. It was his duty as leader to get rid of them all.

Possibly while trading piñon nuts for hides with the Apaches, Don Estéban cooked up a plot to overthrow the Spanish. The plan was that the Apaches were to ride in and steal the Spanish horses while the Spanish were at mass on Holy Thursday, and Don Estéban would lead his Pueblo warriors in a massacre of the Spaniards. Someone in the pueblo sympathetic to the Spanish (or unhappy with Don Estéban's position of power) betrayed the governor, and he was hanged as a traitorous rebel in 1669. A search of his effects after his death revealed that Don Estéban, far from being the pious Catholic the Spaniards thought him to be, was actively practicing his traditional beliefs and hiding "idols, feathers, pollen, and other idolatrous trash." Perhaps the Spanish should have heeded the lessons inherent in this failed rebellion, but they did not; a decade later, Puebloans rose up in rebellion against the Spanish for similar grievances, driving the colonists from the land.

BRAWLING WITH A PRIEST

In 1659, New Mexico saw a change in the secular administration, as well as the ecclesiastical administration, of New Mexico as Bernardo López de Mendizábal and Fray Juan Ramirez arrived on the same caravan to assume the offices of governor and *custos*, respectively. On the way to Santa Fe, they fought so much that some of the incoming priests abandoned their mission and returned to Mexico. This battle between the secular and ecclesiastic powers was fought with words on the governmental level but with guns and knives on the parochial level.

One of the major bones of contention was paying for native labor, a policy to which the priests were solidly opposed. By the time they arrived, Governor López had made up his mind to raise the minimum wage for native labor to one real per day (one-tenth of a peso). Governor López claimed that the friars were growing crops and raising livestock far in excess of what they needed and, to enrich their missions, were requiring labor from every able-bodied person in many pueblos.

To test his claim that the priests were not feeding the natives with the livestock they were using, he set a limit on livestock exports, which the religious promptly violated, exporting three times the limit, claiming that they had to purchase necessary supplies for their churches. An inventory from that period shows what the priests were buying: silk, lamé and damask robes; wrought silver

services; organs; harps; horns; decorated banners; artwork; and fine linens.

Nicolás Aguilar traveled with Governor López as his right-hand man. Aguilar was a miner from Parral—"of large body, coarse, and somewhat brown, a *mestizo*, a reputed murderer, and an accused heretic." Aguilar had murdered his uncle and was looking for a fresh start in New Mexico. With his gubernatorial backing, he soon found himself married into a prominent mining family and establishing a *hacienda* in Chilílí, as the *alcalde mayor* of the Salinas District. When the young Fray Diego de Parraga took over duties at Quarai, the priest Nicolás de Freitas moved to Chilílí and soon found himself butting heads with Aguilar on a regular basis.

While priests and settlers alike hated López's policies, the pueblos appreciated López for relaxing laws prohibiting their traditional ceremonies and for the minimum-wage laws. Nicolás Aguilar enforced the governor's edicts faithfully, although it earned him no friends. Priests bemoaned the return of the kachina dances; unmarried couples pursuing "illicit sexual relations"; the lack of labor to finish building the large, cathedral-like San Buenaventura at Las Humanas pueblo; and other practices "contrary to the teachings of our Holy Mother Church." Fray Diego de Parraga accused Aguilar of moving into the pueblo at Quarai "merely to prevent the Indians from attending the service of the religious and of the church."

The dispute came to a head one day during mass, when Aguilar began heckling Nicolás de Freitas during service. According to Freitas, Aguilar commanded the congregants to leave, and when they wouldn't, he began shouting at them that the friar preached lies and that what he told them was the truth. In later testimony, Aguilar claimed that he was simply informing the congregation that, except for the cantor mayor and the sacristan, they all should be compensated for their labor. They met afterward over a cup of hot chocolate and exchanged more heated words, Freitas calling Aguilar a "Calvinist heretic [and] a Lutheran." Later, Freitas tried to shoot Aguilar with his pistol, snarling that "he should have no more pleasure with his wife." Showing somewhat less flair, the other priest from Chílílí tried to stab Aguilar on a separate occasion.

Aguilar's downfall came when the women of Tajique pueblo brought a complaint before Aguilar that one of the women in the pueblo bore a child to Fray Diego de Parraga. Aguilar approached the priest, who admitted his transgression privately, and Aguilar went to the pueblo to gather witnesses. Aguilar had no trouble rounding up twenty witnesses who claimed they understood the severity of their claims but that they were absolutely truthful in supporting the allegations. In questioning the witnesses at all, Aguilar had made the mistake of violating ecclesiastical immunity, and the hard hand of the Inquisition clamped down on him. Freitas had the girls whipped, and they recanted their testimony.

With Aguilar under arrest, the Inquisition moved swiftly against López and his wife, Doña Teresa Aguilera de Roche. López was accused of Judaism, exploiting the Puebloans, interfering with mission business and overreaching his judicial authority. The trial of Governor López ended when he died, and a sympathetic panel moved to acquit him and his wife, who spent the rest of her days trying to reclaim her property. Aguilar was convicted, excommunicated and exiled, although his children may have returned to New Mexico under their mother's name, Marquez.

Governor Pino Misses the Boat

The formation of the Spanish *Cortes* at Cádiz gave representatives from New Spain the opportunity to write a constitution for self-governance, a democratic step that shook the farthest corners of the Spanish world. While the California and the Sonoran missions lacked adequate central governments to elect a representative, New Mexico was ready and willing.

When the *alcaldes* and other leading men of the province learned of the 1810 decree that they were entitled to a delegate in the Spanish *Cortes*, they leapt into action. Governor Manrique presided over the group that met in Santa Fe that August to select a delegate, and soon they narrowed down the prospects to three candidates. The candidates drew lots, and the winning straw belonged to

Don Pedro Bautista Pino, a highly respected citizen and resident of Santa Fe.

The honor of being the first New Mexican elected as a representative came with a price tag of about nine thousand pesos, the cost to get to Spain and back. Fortunately, the good citizens of New Mexico raised the money to send their native son to see the king, and Don Pedro was on his way.

Don Pedro Pino had the farthest to travel of all the delegates. His journey took him about seven thousand miles from home, through the Chihuahuan Desert and across the width of Mexico, all of which was rough terrain still populated by nomadic and warlike Indians. Once he reached Vera Cruz, far south on the Mexican Gulf Coast, he could sail through the Gulf of Mexico and across the Atlantic to the southern Spanish port of Cádiz.

Predictably, Pino arrived too late in 1812 to have a say in the formation of the new constitution, but he was at least able to provide the *Cortes* with a report from New Mexico, containing a lengthy description of its paltry resources, the poverty and ignorance of its people and the desperate situation of this colony, surrounded by scores of tribes of "wild Indians" who preyed on the livestock of Spanish and Pueblo alike. He also sounded the alarm about the encroachments of the Americans, an aggressive and godless people who had recently arrived on New Mexico's doorstep thanks to the Louisiana Purchase eight years earlier.

After distributing this heartbreaking dispatch—to officials who proceeded to turn a deaf ear to New Mexico's misery—and spending some time touring Spain, Don Pedro turned again toward home, bringing along a memorable souvenir: an elegant touring carriage.

Only one of Don Pedro Pino's requests on behalf of his native land was granted—a bishopric was established in Durango to give New Mexico better access to necessary clerical services. Maybe it was the fancy carriage or the length of the journey that impressed the *alcaldes*, or it was perhaps the warm and grandfatherly Pino's natural diplomatic skills. Either way, despite his failure to effect serious improvements in New Mexico, a few years later the Nuevo Mexicanos once again elected Pino to represent them in Cádiz.

Once again, Don Pedro Pino saddled up his horses, packed his provisions and set off south along El Camino Real, the royal road that was at times little more than an ox trail through the heart of the New Mexican desert. After braving dunes that bogged horses and wagons alike, cactus-studded desert and the Sierra Madre Oriental mountain range, he finally arrived at the tropical coast. In Vera Cruz, he expected to receive enough funds to buy passage on the boat to Spain.

There was money waiting for him—about six thousand pesos, just enough to pay for his trip to that point. Finding himself in the embarrassing but common New Mexican state of being flat broke, he waited and waited,

but the remaining funds never materialized. Finally, he watched the ship sail without him and reluctantly wrote to the Cortes, "*No obstante sus descos de servir a la patria*" (despite this, his descendants would serve the fatherland). His polite apology has taken on a prophetic tone, as generations of his descendants have served illustriously in New Mexico politics.

After the failure to get their representative across the water, New Mexicans made the motions of electing deputies for the next couple of years, but no one else even attempted the trip. When Don Pedro Bautista turned back from his journey to Cádiz, it signaled the beginning of the end of New Mexico's efforts to remain part of Spain.

GOVERNOR PÉREZ LOSES HIS HEAD OVER TAXES

When Albino Pérez came into office as the head of the newly created Department of New Mexico, Joseph Bonaparte had maneuvered himself into becoming the king of Spain. Bonaparte was busily working to ratify his new government just as Pérez was trying to set up his own government in New Mexico. Although Bonaparte probably never gave two moments of thought to Pérez, surely the opposite was not true, as Bonaparte made edicts that cost Pérez the governorship…and his life.

One of the sweeping changes that Napoleon's brother made as king of Spain was enacting the Code Napoleon

across New Spain. The code required the government to levy taxes on wine, tobacco and salt, among other goods. Unlucky Pérez had to be the one to break the news to the New Mexicans. A new constitution had been written in Mexico City allowing for this direct taxation, and it was clear that the taxable goods would include three of New Mexico's major exports: El Paso wines, salt from the province's extensive and pure deposits and the native *punche*, a form of tobacco.

New Mexicans loved their *punche*, and both men and women smoked it constantly in the form of cigarettes rolled in corn husks. They were not averse to snuffing it when the occasion arose, even though this weed was much harsher than native Virginian tobacco. The Bourbon royal dynasty of Spain had learned the vanity of trying to regulate tobacco exports or to force New Mexicans to smoke imported tobacco, as governors and administrators alike wrote to the king describing the futility of separating these people from their native smokes.

One governor wrote that they "avail themselves of the weed *mata* from the Taos and Pecos Mountains, and the *punche* from the Pueblo Indians…and find themselves in a position to provide, although meagerly, for the satisfaction of the vice of these inhabitants, who at present do not hesitate to smoke any herb that they believe acts as a substitute for tobacco."

Indeed, New Mexicans were so poor that they would not have been able to afford the imported products, and no

more could they pay any taxes selling their *punche*. Although there was not much of a market for *punche* in Mexico, the Comanches liked it very much and would exchange good horses, firearms and even slaves for it.

While the Bourbons had learned to leave the tobacco alone, the Bonapartes had not. So the orders came down, and Governor Pérez, loyal to king and country, had to comply with the law of the land, despite the grumblings of his people. Before long, possibly encouraged by the previous governor and his supporters, but certainly with wide populist support, an anti-tax movement emerged in Chimayo.

On August 3, 1837, a small army of tax protestors gathered in Santa Cruz de la Cañada (near modern Española), where the leaders of this movement issued this manifesto:

> *For God and the Nation and the Faith of Jesus Christ!*
> *The principal points we defend are the following:*
> *To be with God and the Nation and the Faith of*
> * Jesus Christ.*
> *To defend our country until we shed every drop of our*
> * blood in order to obtain the victory we have in view.*
> *Not to admit the Department Plan.*
> *Not to admit any tax.*
> *Not to admit any disorder desired by those who are*
> * attempting to procure it. God and the Nation!*

After making this declaration to rousing cheers, the rebels moved south toward Santa Fe. Alarmed, Governor Pérez tried to muster up a militia of patriots willing to defend the state but failed miserably. He did have some soldiers at his command (although New Mexico's soldiers were always woefully underpaid and badly armed), so he marched them off to meet the rebels moving from Chimayo to the capital.

When they met the rebels at San Ildefonso Pueblo, the governor's men deserted him and joined the rebels. Humiliated, Pérez retreated to Santa Fe. Realizing he was no longer safe in the Palace of the Governors, he headed south to find refuge.

Before he had gone far, a group of Santo Domingo men caught the governor hiding in a farmhouse. He fought with fist and dagger the best he could, but the mob was armed with guns and shot him. They beheaded Pérez and, as legend has it, used his head as David Beckham would use a soccer ball. When they tired of this, they placed his head on a pike and carried it into Santa Fe. That same day, the rebels entered the capital and placed José Angel Gonzales, a *genízaro* (of Taos Pueblo and Pawnee ancestry) from Chimayo, in possession of the palace, thus giving him the honor of becoming the first Native American governor of New Mexico.

His glory did not last long. The previous governor, Manuel Armijo, who might or might not have had a part in igniting the hostilities, definitely took credit for quashing them. He raised his own militia from among the Rio Abajo ranchers,

marched on Santa Fe and treated Governor Gonzales with a summary execution, along with his supporters. He wrote back to Mexico City in glowing terms about his own heroics and bravery and earned himself the governorship once more. Before long, Bonaparte's rule in Spain was also crushed, and the dreaded taxes were never enacted.

A CONSTITUTIONAL RIGHT TO SPEAK SPANISH

New Mexico's bid for United States statehood was hampered before the Civil War by the slave state/free state debates in Congress, but even after the war, it took nearly half a century for New Mexicans to be admitted to the Union. During this time, successive Congresses debated over fifty proposals sent by delegates from the New Mexico legislature and constitutional conventions. Many of the debates in Washington revolved around whether or not New Mexico, well settled for centuries and steeped in its own traditions, was "American" enough. For many delegates from solidly Anglo eastern states, the problem boiled down to language; they wanted to eradicate Spanish from the territory, and New Mexicans, about half of whom spoke Spanish exclusively, were just as adamant about keeping it.

New Mexico did have its champions in Congress, although some were less than helpful. For example, one solution to Americanizing New Mexico was to admit the territory as the state of "Lincoln," which sounded nice and

American, plus it neatly balanced out "Washington." The New Mexicans refused, pleading:

> *The name of New Mexico has been for more than three hundred years applied to this Territory, and the inhabitants have for generations held that name in veneration and desire to perpetuate it in their history as the name of a sovereign State…simple justice to this people demands that they should be permitted to perpetuate the history and achievements of their forefathers by retaining "New Mexico" as the name of the new State.*

Some enthusiasts for statehood thought a compromise could be found between a name that recalled New Mexico's origins and one that didn't so forcibly recall the nation from which the territory had been carved. David Dudley Field's earnest proposal to admit New Mexico as the state of "Montezuma" made it into legislation before being defeated. The Honorable B.S. Rodey's proposal to admit New Mexico as the state of "Acoma" didn't even make it that far.

After an 1876 congressional report denied statehood on the grounds that New Mexicans were "ignorant and degraded," as well as being racially mixed and unfit for self-government, Nuevo Mexicanos tried to separate themselves from their Mexican origins and pointed instead to their long and theoretically pure

Spanish heritage. The one part of their heritage they couldn't—and wouldn't—deny was their use of the Spanish language, and that point kept sticking in the craw of the congressmen debating admission.

Perhaps they had the ear of the Anglo Democrats, who wanted to consolidate their power with provisions that would require the use of English in schools, courts and elections. The mostly Hispanic Republicans countered that the school system should be improved to teach New Mexicans English. This threatened the parochial schools, so the priests used their influence to turn the faithful against any requirements for public education, again delaying statehood.

Five more bills failed to pass Congress, and many more virulent, racist statements were entered in the congressional record. In 1898, New Mexicans enacted a sort of compromise on public education, establishing over three hundred schools. Over a third of the schools were taught exclusively in English, and the rest were taught in Spanish or conducted bilingually. The program was celebrated by supporters in Congress but created another obstacle for statehood.

In 1906, Congress passed an act accepting the admission of the state of Arizona, including the territory of New Mexico. Desperate for statehood, New Mexicans passed the measure, but the largely Anglo population of Arizona Territory voted it down. Arizonans didn't want any part of an educational system that promoted Spanish-language

education or bilingual education. They also didn't want to have to supply Spanish-language interpreters in the courts, as was the custom in New Mexico. Outnumbered three to two, Arizonan delegates were sure that they would be forced to accommodate Spanish speakers even though only about 5 percent of Arizona Territory's population spoke a language other than English.

A new Congress was in session in 1910, but some familiar faces were still there. One was Senator Albert J. Beveridge of Indiana, whose xenophobia and race-baiting had poisoned the statehood debate for a decade. Under his influence, Congress passed an Enabling Act, under which Arizona and New Mexico could enter separately but with two provisions to ensure that only English was spoken. First, the schools must always be taught in English. Second, legislators and state officers must speak enough English to do their jobs without an interpreter.

Shrugging off this mandate, the New Mexicans submitted a constitution that required the state to support bilingual education, protected the educational rights of children of Spanish descent and ensured that Spanish speakers were afforded the same access to election and legislative information as English speakers. When challenged, they deleted the clause requiring legislators to speak English and replaced it with one guaranteeing equality regardless of race or ability to speak English. The framers also slipped in a phrase that required the

secretary of state to "make reasonable effort" to provide notices in indigenous languages. An uproar ensued, but the provisions passed largely unchanged when New Mexico finally gained statehood in 1912.

REROUTING ROUTE 66

Arthur T. Hannett, the seventh governor of the state of New Mexico, rose to power through his honest hard work as a member of the State Highway Commission. This integrity, along with plenty of highway building, was one of the hallmarks of his administration. He signed into law numerous laws related to surveying and building new roads and repairing roads across New Mexico. New Mexicans, who previously had trouble getting around because of bad roads or no roads at all, were appreciative, but a group of Republican politicians who resented his firm stand against corruption were not such big fans.

The "Santa Fe Ring," as it was known, was made up of rich and powerful attorneys and landholders who planned to stay that way. They had gained nearly total control of the state some fifty years before and had become notorious by inciting some of the uglier incidents of the Colfax County War by evicting squatters from the Maxwell Land Grant.

Hannett had beaten one of them, Holm Bursum, in the 1924 election for the governor's office. That

a functionary from the Highway Commission could overcome a member of the Santa Fe Ring was only possible because Bursum was under investigation for abuse of office, corruption and embezzlement during the election. But Bursum and his wealthy friends in the Santa Fe Ring bided their time patiently until the next election. Then they put the power of their wallets behind smearing Hannett in the press.

After being accused of patronage and nepotism (although he had fought exactly that), Hannett lost the 1926 election. Early in November, with only a few weeks left in his term, he decided to play a nasty trick on the incoming governor, Richard Dillon, who owned a large sheep ranch near Encino. Looking at his maps, Hannett realized that his trick could be extended to give a black eye to the whole rat's nest of crooked politicians in Santa Fe.

He traveled to where work crews were building a highway that was supposed to connect roads from Amarillo to the roads out of Santa Fe following a tortuous route up through the Encino area, thanks to the influence of Dillon's money. He outlined his new plan: the new highway would not veer north at all and in fact would not ever reach Santa Fe. Instead, the new highway from Texas to Arizona would follow a direct east–west line…straight through Albuquerque.

The highway crews, who expected to be unemployed after the next governor was sworn in, liked Hannett's joke

and particularly liked that it would discomfit Dillon, who was counting on the new highway to improve his sheep business. They set to work with a will, one crew working east from Moriarty and one crew working west near Santa Rosa. They yanked out piñon trees and flattened sagebrush-studded hills, operating their army surplus caterpillars, graders and tractors at full capacity.

Dillon and the other residents of Encino, Romeroville and Vaughn watched helplessly all through December as the two crews approached each other. Perhaps funded by the same bottomless pockets, and perhaps motivated only by the prospect of being left off the beaten path forever, residents of these communities tried to sabotage the project. They vandalized equipment, pouring sugar in the gas tanks and sand in the engines of the vehicles, but to no avail. The loyal highway workers, devoted to their champion, forged ahead.

Finally, on January 1, 1927, Governor Dillon was sworn into office and immediately moved to stop the work crews. He sent the state engineer out to halt construction. The engineer drove off in a hurry, but a freakishly bad snowstorm delayed him. When he finally found the workers on January 3, he found that they had worked through the blizzard and finished the road, meeting at Palma, now known as Cline's Corners.

To his credit, Dillon was able to take the joke in stride; he not only left the finished road as it was, bypassing his own property and the capitol, but he also rewarded the highway

workers for their loyalty, kept them all in their jobs and applied for new federal funding to pave the road that had become known as "Hannett's Joke."

After the federal government paid for paving, the road became part of the new U.S. Route 66. While it was not a major city before construction, the population of Albuquerque tripled in size by 1950 and doubled again in the next decade—which many felt was thanks to the "Mother Road." Although Arthur Hannett did not live to see it, his joke had the intended effect; becoming the hub of interstate transportation contributed to tipping the balance of power in the state.

Part III

SPIES, SMUGGLERS AND TRAITORS

THE LIES OF GOVERNOR PEÑALOSA

Don Diego de Peñalosa arrived in New Mexico to serve as governor shortly after the previous governor and his wife were arrested by the Holy Office of the Inquisition. Upon learning of their capture, he immediately ransacked his predecessor's house, hauling off everything of value, including six hundred marks of silver and the former governor's bed. He claimed to be taking them on behalf of the Inquisition but never returned any of the goods.

Peñalosa allied himself with the hotheaded Fray Nicolás de Freitas and sent the priest to illegally collect, and deliver to the governor's office, the *encomiendas* of citizens who had been arrested by the Inquisition. Fray Freitas helped Peñalosa spar with the Holy Office for a while but then disastrously advised him to arrest the custodian and head of the Holy Office, Fray Alonso de Posadas, after Posadas threatened excommunication for Peñalosa, who, besides stealing the Inquisition's money, lived openly with Luisa Barrios, his wealthy socialite concubine.

Upon learning that Posadas had been arrested and imprisoned in the Palace of the Governors, the priests of New Mexico destroyed all the sacramental wafers and wine in the province as a protest. Peñalosa realized he was in over his head and released the Fray *custos* on pain of secrecy, but before long, word reached the headquarters of the Holy Office in Mexico, and a warrant was issued for his arrest. Trying to stay one step ahead, Peñalosa packed up

the silver he stole (which the previous governor may have stolen from his predecessor) and, with his mistress, fled for Parral with the royal banners flapping from his carriage.

As fast as Don Diego could gallop, he could not escape the long arm of the Spanish Inquisition. The authorities arrested him in Mexico City and, after a three-year trial, found him guilty in 1668: "On the 3d of February, 1668, the tribunal of the Inquisition celebrated an Auto de la Fé in Santo Domingo, in which Don Diego de Peñalosa, Governor of New Mexico, was condemned to penance 'for his unrestrained language against the priests and lord inquisitors and some absurdities that bordered on blasphemy.'" The formerly mighty governor was forced to walk the streets bareheaded and holding a green candle to demonstrate his penance.

Although his public penance was comparatively mild, Peñalosa was also banished from New Spain and prohibited from ever holding public office again. Understandably grieved against his fatherland, he sailed to England and offered to help Charles II move against the Spanish. The English king wasn't interested, so Peñalosa crossed the channel to put his proposition before the French. He suggested establishing a colony at the mouth of the Rio Bravo (the Rio Grande) on the Texas coast, from which the French could march on the Spanish territories and seize their rich mines. No doubt Peñalosa imagined himself heroically leading the charge and personally sticking it to the people who had humiliated him.

During this time, a very odd book appeared, ostensibly published by Peñalosa's old ally, Fray Nicolás de Freitas. Omitting the one-hundred-word honorific for the governor's name, the title in English is *The Relation of the Discovery of the Country and City of Quivira, Made by Don Diego Dioniosio de Peñalosa...in the Year 1662*. The book describes a rather heroic journey that Peñalosa took to explore the rich and fabled lands of Quivira. Although it has since been thoroughly debunked as malarkey from start to finish, it was enough to convince the French that Peñalosa was familiar with the interior that lay between French and Spanish territories and could be trusted to plan an expedition.

Embroidering on this tale, Don Diego optimistically described to the French the benefits of a colony on the Gulf Coast of Texas, including proximity to the colony of Santo Domingo, navigable rivers, a temperate climate and rich soils, but best of all, "under good leaders" the colonists would "make an important conquest for his [French] majesty," namely: invade New Mexico. Obviously, he saw himself in the role of a "good leader," forgetting that his previous administration had brought him into conflict with both the Inquisition and New Mexico's citizens.

Peñalosa's proposal was dismissed until Father la Salle, who had recently completed his exploration of the Mississippi River, suggested a similar plan to establish a French settlement at the mouth of the great river as a

jumping-off point for invading Spain. Peñalosa caught wind of this and began spinning a happy fantasy: "The enterprise of the Count de Peñalosa and that of the Sieur de la Salle will serve to support each other…and these two commanders will then be able to aid each other…and divide their conquests…into two fine rich governments, which will bring every year considerable wealth to France and a new glory to his majesty for having extended his victories and conquests to the New World."

With two "commanders" (fraudulent as the one was) promoting such a plan, the king acquiesced, combining the two projects and sending La Salle with four ships to Texas in order to pave the way. La Salle loitered on the Gulf Coast for a year waiting for Peñalosa. The priest-explorer did not try to start a colony, plant crops, negotiate with the natives or establish trade; he just waited. His four ships, lying idle off the coast, foundered and sank. Perhaps Peñalosa was trying to pull strings in Paris to return to the New World, but probably not. More likely, Peñalosa decided exile in Paris was better than a dubious military expedition through the desert.

The great explorer and French hero La Salle sickened and died in 1687 while waiting for Peñalosa to show up and invade New Spain with him. Peñalosa also died that year, in presumably more comfortable circumstances in Paris.

THE LURE OF FRENCH IMPORTS

While British colonists forged a life on the Atlantic coast, the French claimed nearly the entire interior of the North American continent, and the vast territory of Louisiana bordered northern New Mexico. On these French-Spanish borderlands, north of Taos and east of the Arkansas River, old and bitter European rivalries played out on a small stage. The French and Spanish monarchs had been steadfast enemies for generations, and the Spanish king decided to erect an economic wall on his northern frontier. In 1723, he issued a decree prohibiting trade with the French, and the news soon trickled down to Governor Juan Domingo de Bustamante.

Bustamante was aware of the French menace, trappers drifting west from the capital on Mobile Bay. He issued an alert to his countrymen to watch out for the pernicious Francophones. He was aware of reports that some Frenchmen were visiting the Pueblo of Pecos in 1695–96, although by the time the alarm had been sounded, the wily traders had vanished. None of the Pecos people were any help in identifying them or tracking them; perhaps they appreciated the quality of the firearms the French were able to sell them.

All New Mexicans coveted the fine guns the French carried, which were much more effective than arrows or the antiquated Spanish harquebuses. One of the reasons New Mexicans wanted the French guns so badly is that their sworn enemies, the Comanches, had them. The French

had been profitably trading with the Comanches at a site up around Kansas for some time. The combination of the speedy Spanish mustangs and reliable French weapons gave these bands a formidable advantage against everyone in their path. New Mexicans had resorted to taking ever more defensive measures against the raiders, including building *torreons* (watchtowers) near *haciendas* and villages and clustering their houses more defensibly.

New Mexicans needed better arms, and the only way they could get them was to trade with the French, even if it violated all their laws and their patriotic sensibility. Merely a year after Bustamante issued his decree, reports started trickling in about Frenchmen trading with residents in and around Taos. Again, no one ever reported seeing a Frenchman, and certainly no one admitted to trading with one, but the goods were indisputable evidence of illegal activity. Possibly there were no Frenchmen intruding into the Spanish realm. The goods might have come by way of the Jicarilla Apache, who very much liked French guns and needed them after the Comanches had wiped out all but half their women and children and sixty-nine of their men. They certainly felt no compunction about disobeying Spanish law in the interest of arming and provisioning themselves.

Of course, the French weren't just trading guns. With convenient ports in the city of Nouvelle Orleans, the French traders often carried thousands of dollars' worth of goods, including fine linens and sturdy ironware, both

of which necessities were sadly lacking in New Mexico. Because of the prohibition against trade outside Spanish domains (except with native groups), anything that could not be produced locally had to sail from Spain, be processed through the Spanish bureaucracy and somehow find its way over a thousand miles, through forbidding desert and hostile tribal territories. By the time goods arrived, the expense of freighting them was out of proportion to the value of the goods, and few New Mexicans could afford such luxury. In contrast, the French goods were transported a much shorter distance and were relatively cheap.

Armed with inexpensive trinkets, liberal trade policies and easygoing ways, French traders like Louis Juchereau de Saint-Denis steadily expanded their reach and their influence among the Plains tribes. The Comanches enjoyed aggravating the Spaniards and left the Frenchmen unmolested. The borderlands trade grew, and more New Mexicans risked death or jail in return for cheap French goodies.

The letters that Bustamante submitted to his government indicated he was doing all he could to prevent his people from leaving the province to trade, prosecute smuggling and diligently protect New Mexico's extensive borders against the invaders armed with excellent liquor. When he left office and the next governor held the official *residencia*, the truth came out when the Pecos mission priest spoke up.

Fray Pedro Antonio Esquer believed Bustamante to be a blaspheming, venal and corrupt leader who extorted,

intimidated, perverted and tyrannized the entire populace. In his testimony, he recounted how cronyism and swindling poor soldiers and Indians had earned Bustamante's father-in-law and uncle enough money to buy his nephew the governorship for 20,000 pesos. He elaborated on the theme of gubernatorial corruption by describing how nine years in office had enriched Bustamante by some 200,000 pesos. In addition to this trove, Bustamante had also amassed "wrought silver, coach, slaves, household furniture, pack train with not a few draft mules, and not a few horses." Although Fray Pedro did not specifically accuse the former governor of trading with the French, it was clear how he had gotten so rich.

Because of Esquer's testimony and that of other citizens, formal charges of smuggling were brought against the governor. He admitted to trading with the enemy French but mounted a compelling argument that the trading was "for the good of the nation," bringing security and wealth to a colony that desperately needed both. The court admitted the validity of his argument but convicted him anyway, sentencing him to pay the costs of his trial.

Notorious Dr. Robinson

Zebulon Pike had almost finished assembling men and preparing for his 1806 westward expedition when Dr. John Robinson joined the crew as a surgeon and naturalist. The

party certainly needed a doctor, and Robinson would have been welcome in any case. But rumor had it that he had the backing of a shadowy sponsor, perhaps the conspirators General James Wilkinson and Aaron Burr, fomenters of the Burr Womptompartyuip conspiracy, which aimed to carve a nation of its own out of American and Spanish territory. Supporters of this theory point to the fact that Robinson was not the typical footloose frontiersman in search of adventure; he had a lovely young wife back in St. Louis, a good job and influential connections.

Possibly, Lieutenant Pike's party of explorers didn't mean to cross the boundaries of New Spain, an act they knew was considered illegal by the Spanish government. When a miserably cold winter came upon them suddenly, they took shelter in the Rocky Mountains, on the northern fringe of New Spain. In February, Dr. Robinson left the group to ride alone into the forbidden territory of Santa Fe. He had a plausible reason—to collect a debt on behalf of a friend—but Pike admitted in his notes that the group had seized on that story as an excuse to scope out a place Americans had never seen.

The Spanish doubted that anyone would go hundreds of miles across the Plains to collect a debt for a friend, but it was true that the trader Jean Baptiste La Lande had stolen his partner's wagon and migrated to Santa Fe some years before. While they sorted out that matter, a detachment was sent to collect Pike and the rest, who came along peaceably, cold and hungry as they were.

The New Mexican governor, Joaquín del Real Alencaster, realized that he was in way over his head. He couldn't tell if they were spies or simply hapless, and the significance and consequences of an American military expedition crossing the border was unimaginable, so he did what any good functionary would do: he bumped the problem up the chain of command. This required a long march for the not-quite prisoners down to Chihuahua to meet General Nemesio Salcedo, the *commandant general* in charge of New Mexico and Texas. En route, they were prohibited from seeing any maps of the interior of New Spain. Despite this, Pike sketched a map as best he could, based on whatever interesting facts their escort, the friendly Captain Antonio D'Almansa, let slip about the geography.

When Pike arrived in Chihuahua two months later, Pike and Robinson were still not imprisoned, but neither were they free to leave. During the month they spent cooling their heels in Chihuahua, the Americans were approached at social events by men who believed it was high time to end ties with the Spanish monarchy, as the Americans had with the British. Pike was polite and noncommittal, but Robinson seems to have been more deeply affected. He returned to General Salcedo with an astounding offer: he would explore and guard the northern region on behalf of New Spain if Salcedo would let him become a "subject of His Catholic Majesty." Salcedo would hear nothing of the defection and sent Robinson packing, along with Pike, back to the United States via Texas.

The rejection from Salcedo must have stung Robinson, and he determined a plan to get even. In 1812, he convinced Pike, who had become a national hero, to arrange a meeting between Robinson and Secretary of State James Monroe, who was worried about filibustering schemes like those of Burr and Wilkinson and wanted to prevent a war with Spain. He agreed to send Robinson as an envoy back to Chihuahua to meet once more with Nemesio Salcedo and persuade him that the United States had no intention of invading New Spain and that all the border negotiations could be arranged amicably.

Perhaps it was because Robinson had already shown himself to put his own interests before those of his country, or perhaps it was because Robinson had met with the revolutionary leaders on his way through Texas, but Salcedo did not trust the man. In fact, he let his aristocratic pride run away with him and ended up impugning not only Robinson's personal character but also the character of the entire United States of America. When Robinson protested he had come on an errand of peace and national honor, Salcedo snarled, "You speak of national honor—a government, formed by an unlawful act—and came into existence only yesterday—formed by people who can remain in no other governments—a government that has not power to restrain her Subjects—the conduct of your government towards Spain—and yet you speak of national honor…"

Enraged, Robinson ripped off a ranting, voluminous letter to Monroe and marched off to meet with the leaders

of the Republican Army again, totally committed to overthrowing this arrogant and infuriating government. After he issued several communiqués from his office of special envoy to the secretary of state in support of the populist revolution, an embarrassed Monroe quickly moved to terminate his employment. Freed, Dr. Robinson once more traveled down into Mexico and signed up with the Mexican Republican Army, rising to the post of brigadier general. Even if he had been totally innocent when he first arrived in New Mexico, he was determined now to destroy the system entirely.

After about eighteen months of fighting, and deathly ill from yellow fever, he retired from his post and returned to Natchez, Louisiana. His final years were spent fighting for the cause in a quieter way, drafting manifestos for Americans to support the Mexicans against the "European menace" and a monumental, six-sheet wall map of western North America, showing how much land the Unites States stood to lose if the government accepted the boundary claims of the Spanish. Robinson died at the age of thirty-seven and did not live to see Mexico achieve independence.

AMERICAN FUR TRADER IN NEW MEXICO

The celebrated mountain men of the Rocky Mountains worked without regulations, but fur trappers in New Mexico had to contend with an existing government, under

which American fur trading was nominally illegal. James "Ohio" Pattie was one fur trapper who tried and failed to make a living trapping in New Mexico, in part thanks to the caprices of the government. From one year to the next, his immigration status was in doubt, as was the legality of his trade.

When Pattie arrived in New Mexico with his father, Sylvester, they were among the first Americans to take advantage of the new trade laws of the brand-new Mexican government. After breaking with Spain, the Mexicans eased the long-held restriction on New Mexicans who wanted to trade with their northern neighbors. Hoping that a fortune in beaver pelts awaited them on New Mexico's waterways, Pattie and his father had braved the long trek to the town of Santa Fe. Governor Bartolomé Baca considered their proposition to trap on the Gila River but disappointed them by answering that he could not legally permit them to do so. They offered the governor a bribe of 5 percent of the pelts, which he agreed to take under consideration. Pattie complains rather justly, "The thoughts of our hearts were not at all favorable to this person, as we left him."

Governor Baca was indeed being a bit coy with the Patties. The law did prohibit Americans from trapping in New Mexico, but Baca certainly had the authority to issue licenses, as there were no Mexicans interested in trapping. Perhaps he would have accepted the bribe, and perhaps he would have held out for more, but in a dramatic turn of events, his daughter, Jacova Baca, "a beautiful young lady,"

according to Pattie, was abducted by Apaches. The Patties rode off immediately and successfully rescued her. Baca could hardly hold out on them after such a feat of derring-do and awarded the Americans the license they sought.

A miserable winter followed for the men, as they lived on mesquite beans, ravens, buzzards, dogs and cactus. According to "Ohio" Pattie, they fought a grizzly bear and mountain lions, almost froze several times, fought with and then made peace with the Apaches and secured several hundred beaver pelts in a cache. Sadly, the cache was discovered (Pattie suspected Apaches), and "the whole fruit of our long, toilsome, and dangerous expedition was lost, and all my golden hopes of prosperity and comfort vanished like a dream."

Ohio Pattie decided to trap another year and joined up with already famous mountain men Ewing Young and Milton Sublette, who had a license to trap from Baca's successor, Governor Narbona. Pattie Sr. decided to try renting the Santa Rita del Cobre copper mine, a rich deposit in southern New Mexico that is still in production. The trappers worked their way up the Gila to the Colorado, the first Americans to do so, and brought "a fine amount of furs" back to Santa Fe.

There they got a nasty surprise. In their absence, Governor Manuel Armijo had succeeded Narbona and confiscated all the furs on the pretext that he had issued no license to the party, so their take was illegal. The Americans were "excessively provoked," to say the least. Sublette got

lucky and spotted two bales of furs that had been spread out to dry, scooped them up in full view of the entire garrison and ran like the wind into a nearby house. Armijo threatened the Americans with cannon fire, but Sublette was able to smuggle his furs out of New Mexico and back to the United States. Pattie was not so lucky.

He returned to the mines to help his father but again met with misfortune in the form of a dishonest clerk, who absconded with thirty thousand gold pesos. Pattie quickly discovered that tracking the clerk was hopeless and turned to the government for redress, with the same negative results. Despairing, he traveled to Chihuahua and consulted with the mine owner who had been so kind to him and his father.

But the mine owner was also suffering from the whims of the government. On December 20, 1827, Mexican president Guadalupe Victoria had decreed the expulsion of all Spaniards from the republic. Wealthy Spaniards had tried to spark a rebellion, and President Victoria was outraged enough to punish all Spanish-born residents. The mine owner had been given one month to get his affairs in order and leave the country. He could not save the Patties, so they returned to trapping, determined now to leave New Mexico behind.

The Patties made their way to San Diego and again fell afoul of local authorities, who suspected the passports from Santa Fe had been forged and threw them into prison. Sylvester died in prison without ever seeing his son again. Ohio Pattie stewed in prison for years, trying in every way

he could to gain freedom for himself and the men of his party, including fighting for the Spanish against the mostly American insurrectionists. Finally, the winds of government shifted again. Pattie received a pardon and was free to return to the United States, which he did in short order, although absolutely impoverished. Perhaps as a last-ditch effort to make some money from his New Mexico adventure, he published a somewhat embellished account of his travels the following year, *The Personal Narrative of James O. Pattie, of Kentucky*. Despite his colorful moniker, Ohio Pattie did not get rich from his writing either, though his account certainly inflamed Americans against the corruption of the Mexican government and Manuel Armijo in particular. Pattie probably died in a cholera epidemic in 1833.

SURRENDERING TO THE AMERICANS

Perhaps more than any other New Mexico governor, Armijo embodies the love-hate relationship New Mexicans have had with their politicians. General Manuel Armijo is forever marked in history as the last Mexican governor of New Mexico, but the circumstances surrounding his surrender to American forces remain a topic of controversy, as do many of the actions of his three terms as governor. After their bloodless invasion, many Americans alleged that he accepted a bribe, while his supporters continue to try to clear his name to this day. Although Armijo's surrender

is one of the most famous turning points in New Mexico history, the truth becomes more obscured with time.

Rumors about Armijo's corruption and scheming have been repeated enough that although some have been debunked—like the story that he got his start by stealing sheep—some are still in doubt. After Armijo left the office of the governor for the first time, a rebellion rose up against his successor, Governor Albino Pérez. Was Armijo pulling strings to incite the rebels, as trader Josiah Gregg alleged? Was it true that he assembled a militia to overthrow the rebel government out of spite that he hadn't been returned to office? Did he really have Governor Gonzales executed to keep him from revealing his part in the plot? No evidence supports this story, although it's conceivably true. However, Gregg hated Armijo and happily repeated any disparaging story he heard about the governor.

Armijo was a skilled self-promoter and painted such a heroic picture of himself as the savior of the republic that he was returned to the governor's office. During Armijo's second term, he found himself walking a fine line between being a loyal representative of the Mexican government and the trade emissary and de facto ambassador for the Americans, whose traders were pouring over the border in ever-increasing numbers. He made huge land deals with some Americans who had become Mexican citizens. Despite levying stiff tariffs—the Mexican government had "forgotten" to fund his administration—he generally made the traders welcome, even though he was concerned about

how much they were smuggling out of his country. But when some Texans invaded in the expectation that New Mexico would join them in a bid for independence, Armijo tricked them into surrendering and then had them brutally marched down to Chihuahua for trial.

The whole catastrophic misadventure was recorded by a reporter for the *New Orleans Picayune*, whose gruesome and extremely biased tale raised general indignation across the border. Riveted readers across the United States learned with horror that Armijo was "an assassin, a murderer, a bloodthirsty tyrant," whose power had been "purchased by blood...[and] was sustained with blood." Few stopped to think about how their governors would react if a group of mostly foreign secessionists invaded their states. Instead, it fueled the popular sentiment that those lands would be better under an American government.

Texas sent a second force to retaliate, and the New Mexicans who met them in battle on the Plains were roundly defeated. Armijo had been following the action from a distance and quickly retreated to Santa Fe—some joked that he left bits and pieces of luggage in his trail—and shortly thereafter resigned due to ill health. Armijo summarized his border trouble: "Poor New Mexico! So far from heaven, so close to Texas!"

Such was Armijo's force of personality that his successor, Mariano Martinez de Lejanza, only lasted in office for a year. Despite the perception of Armijio's cowardice, New Mexicans and Americans alike realized they preferred his

free and easy ways when Lejanza tried to raise both tariffs on Americans and taxes on New Mexicans. Manuel Armijo was soon Governor Armijo for the third time. Before he had been back in office a year, he heard that the Americans were gathering for an invasion.

Armijo rallied the populace to fight against the invaders, but his heart was not in it. He also wrote to Mexico for more troops, without holding out hope that he would get a response, much less the soldiers, arms and horses that he needed to repel the nearly two thousand troops advancing toward his capital. He quietly liquidated his shares in American partnerships and arranged his affairs in the event of his absence.

By the time the Americans arrived, he had assembled a ragtag troop of about 1,900 enthusiastic recruits, with no training, inadequate weapons and little food, as well as 75 trained soldiers dragging a cannon. He sent them out to a position on the Santa Fe Trail where they might be able to block the Army of the West, and then entered into one final parlay with Captain Philip St. George Cooke and the wealthy El Paso merchant James Magoffin. Magoffin had been selected by the president for this purpose as being uniquely able to "prevent any armed resistance on the part of Governor Armijo and his officers." Perhaps it was so, for shortly before the Americans reached Apache Canyon, Armijo rode out and forced all the defenders to go home. Armijo himself took his dragoons as an escort down to Chihuahua, where he remained for the duration of the war. Kearny occupied Santa Fe shortly thereafter, without firing a shot.

Again, speculation swirled around Armijo's actions, but the truth remains obscured. Did Armijo accept a bribe? A tribunal in Mexico acquitted him of wrongdoing, but generations of historians contend that he did. The only evidence that would support this claim is Magoffin's request for reimbursement from the U.S. Treasury for $50,000 for "services rendered." Increasingly, historians advance arguments that a bribe would not have been necessary for Armijo to accept the inevitable and act to save his countrymen from certain death. Some armchair strategists argue that Armijo could have held Apache Canyon, while others dispute the readiness of the New Mexican volunteers.

In recent years, Armijo's descendants have been working to rehabilitate his image and recast him as a patriot who bravely fought for his country's integrity, against rebels from within and invaders from without, until faced with an implacable force. Family tradition holds that Armijo was "vilified" and a "scapegoat" for the Americans to justify their seizure of New Mexico. One of Armijo's descendants defiantly claims, "I am proud that my ancestors realized that it would be better to become part of America."

KIT CARSON'S NAVAJO SCOUT

As late as the 1960s, Navajo elders still remembered Jesus Arviso, who was born to a *Naakai* (Mexican) family but grew

up among the *Diné* (Navajo) and became a famed warrior hired by the Americans for his fearlessness, his easy way with languages and his uncanny tracking skills.

Jesus was captured by Apaches when quite young. According to some oral histories, he ended up as the property of the young warrior Geronimo. Around 1830, a band of *Diné* were visiting Cochise's band of Chiricahua Apaches to do some trading. Geronimo became enchanted with a beautiful black horse owned by the *Diné* warrior Red Hair. When pressed to trade, Red Hair struck a deal for the little *Naakai* boy and brought him back to *Dinetah*, the Navajo homeland surrounded by four sacred mountains. Jesus Arviso was adopted into the Salt clan and grew up in Red Hair's family, becoming fluent in the Navajo language and lifeways. Eventually, he married a Navajo woman and had many children. Everyone who knew him remarked on his abilities as a warrior and on his intelligence. He continued to speak perfect Spanish and even learned some English when the Americans began coming around.

Despite having a wife and many children, Jesus was happiest riding through the rugged mountains and canyons of his homeland with a band of his brothers. When the U.S. Army troops arrived to start removing all the *Diné* from their homeland, he took to the backcountry and evaded capture for several years. During this time, Arviso's wife and children were captured and exiled to *Hwéeldi*, the place of imprisonment and dread, also known as Fort Sumner or Bosque Redondo.

Eventually, Arviso tired of hiding and being separated from his people and determined to surrender to a detachment patrolling around Zuni. The soldiers, who took him for a Navajo, tied him up and headed toward the fort near San Rafael. En route, some Zuni warriors attacked, and the frightened soldiers unbound Arviso so he could help defend them. He acquitted himself with so much skill that the army men warmed to him, and before long, some of the Hispanic New Mexican soldiers discovered his linguistic skills. A job offer to become a U.S. Army interpreter was not far behind, and Arviso was in no position to refuse.

Major Eaton of Fort Wingate understood the value of Arviso's knowledge and gave him the order to round up the remaining bands of *Diné* from their hiding places throughout *Dinetah* and convince them all to surrender. The army had been systematically destroying crops and fruit trees in the hopes that the starving Navajo would be more likely to surrender. Some elders, in describing that tragic time, attribute their eventual capitulation more to the terrible persistence of the Pueblo warriors, who had suffered one insult too many from *Diné* raiding parties.

Be that as it may, Arviso was able to locate many bands of his adopted kinsmen and convince them to make the Long Walk to *Hwéeldi*. In 1866, Arviso convinced the great leader Manuelito, who had watched his father be murdered during peaceful negotiations with the Americans, to surrender his people. Arviso persuaded the old chief that there was more pride in surrendering than in being captured. As one elder

from Tohatchi said, "During the Kit Carson days…he was one of the best army that they had." On the difficult march to Fort Sumner, Arviso was in the uncomfortable position of captor, driving his people away from all that they held dear. Somehow, he managed to balance his duties to his people and to his employer well enough that he was elected as a leader among his people in Fort Sumner.

As the army interpreter, he learned that the Americans were planning to send the Navajo to Oklahoma, a fate worse than death. The imprisoned *Diné* talked for a week, strategizing how to convince the army to let them return to their sacred homeland. Arviso helped Barboncito negotiate the terms of their return to *Dinetah*. Together, they put their case before General William Sherman, who had taken over the disastrous project after its progenitor, General James Carleton, was relieved of command. Even Sherman could see that the Navajo (the Mescalero Apache at Fort Sumner had long since slipped back to their homeland) would never flourish at Bosque Redondo. He noted that the once-proud people had "sunk into a condition of absolute poverty and despair" in the unfamiliar and hostile land of eastern New Mexico.

Working with Spanish interpreter James Sutherland, Arviso translated his elders' words into Spanish, and Sutherland translated them into English. In this way, the *Diné* leaders and the army worked out an agreement in 1868: The *Diné* would return to their homeland on the condition that they would forever cease their hostilities against other

New Mexicans and allow their children to go to American schools. In return, the government promised them sheep, goats, agricultural implements and other goods, as well as the return of all Navajo children held as slaves by the Hispanic New Mexicans.

On their return, Arviso and Manuelito settled in Tohatchi, and Arviso lived until 1923, long enough to see the U.S. government fail to honor any of the treaty terms. Perhaps this soured relationship also affected the *Diné* perception of their adopted son, Jesus Arviso. Although many *Diné* remember Arviso with fondness and respect, bitter words are still spoken about the "Enemy Navajo," who led Colonel Kit Carson to the Navajo hiding places. Was Arviso a hero to his people, an Enemy Navajo or a Mexican trying to get by on his wits and quick tongue after being stolen from his birth family and sold into an unfamiliar culture? Linguistically gifted but illiterate, Arviso left no written record of his innermost thoughts. However, those closest to Arviso, particularly Manuelito's descendants, are unwavering in describing him as devoted to the well-being of his adoptive people and homeland.

THE SPY WHO WENT FREE

Security around the Manhattan Project was so tight that the scientists on the project constantly watched and

controlled, with army intelligence checking their mail and noting all suspicious behavior. Despite this scrutiny, three men were able to smuggle secrets out of Los Alamos and into the hands of the Russians. While Klaus Fuchs and David Greenglass served long prison sentences for their crimes, and Greenglass's sister and brother-in-law were executed for their alleged role, Theodore Hall escaped all punishment.

None of the three knew of the others' involvement, although a man named Harry Gold ferried information supplied by both nuclear physicist Klaus Fuchs and machinist David Greenglass. The 1945 discovery that Fuchs was serving the KGB led to the investigation of Harry Gold and on to David Greenglass. Popular sentiment ran high against these men and all who aided them. Scientists who had frequent contact with Fuchs were interrogated; even the women who typed up their papers came under suspicion.

Fuchs confessed, as did David, although he admitted later to hiding his wife's role as the typist, instead implicating his sister, Ethel Rosenberg, and her husband, Julius. Although the Rosenbergs were sympathetic to the Communists and Julius encouraged David's involvement with the Russians, Ethel was probably not involved at all. Despite the flimsy evidence against them, Julius and Ethel Rosenberg received the harshest sentence for the leaks at Los Alamos: they were executed in 1953.

But what of Ted Hall, born Theodore Holzberg, who at the tender age of nineteen became the youngest scientist

to work on the Manhattan Project? The brilliant young physicist had distinguished himself at Harvard enough that his professors urged him to accept an assignment on the new top-secret government project. When he found out what they were working on, he pondered long and hard. Was it right for one government to have such a terrible weapon? Weren't the Russians our allies, and shouldn't we be sharing our technology with them as we were with the British? These thoughts kept him awake at night between marathon work sessions.

Hall took a vacation and traveled back east to visit his family. In New York, he reconnected with his roommate from Harvard, Saville Sax, and explained the situation to him. Sax went to a Soviet cultural propaganda agency in New York City on behalf of his friend. Hall had to get back to Los Alamos soon, so Saville pressured the Russians for a response, and they finally relented, unsure whether such young boys could provide them anything of interest.

But Hall, with Sax acting as his courier, delivered in spades. He supplied the process for refining the plutonium and building the trigger mechanism, as well as detailed diagrams of Fat Man, the bomb dropped on Nagasaki. His information confirmed the data from Klaus Fuchs; both were probably more useful than Greenglass's sketches of implosion lenses. His information may have been more useful for actually building the bomb than that supplied by Fuchs. Hall was responsible for designing the

trigger so that it would produce the pressure necessary to start a chain reaction and ignite a nuclear explosion.

The information was transmitted through an encryption system the Soviets thought was impenetrable. Actually, American and British intelligence agents had cracked it within a few years and just didn't let on, instead deciphering the messages as part of a highly secret program called VENONA. The deciphered messages gave the government its first clue, in 1946, about the espionage at Los Alamos. Rather than blow the cover of this program, prosecutors waited to prosecute Fuchs until 1950, when they had gathered enough other evidence. Even so, the backlog of messages was tremendous and took forty years to fully decipher. During that time, analysts realized that there was a third spy at Los Alamos.

Again and again, this spy and his courier were referred to in code, "young" for the spy and "old" for the courier. Finally, in 1951, they found the damning evidence: a reference by name to "Teodor Kholl" and "Savil Saks." The FBI questioned Hall, but he stood his ground and revealed nothing.

Government prosecutors were in a quandary. They couldn't move against Hall without revealing the VENONA project, which was revealing other, more dangerous spies. If they used the information without sourcing it, it would be inadmissible as hearsay evidence. In the end, VENONA was too important to risk, and prosecutors had no other evidence against Hall or Sax. Hall continued to distinguish

himself as a scientist in the field of biology, where he pioneered the use of X-ray microanalysis.

After the fall of the Soviet Union, VENONA was declassified, and the story of Hall's role as a Cold War spy emerged. Hall, who was ill with cancer and Parkinson's, decided to shrug off the burden of secrecy he had carried for forty years. In a 1998 interview with CNN, he said, "I decided to give atomic secrets to the Russians because it seemed to me that it was important that there should be no monopoly, which could turn one nation into a menace and turn it loose on the world as...as Nazi Germany developed. There seemed to be only one answer to what one should do. The right thing to do was to act to break the American monopoly."

Part IV

WITCHES, PRIESTS AND MYSTICS

Fray Juan's Deadly Journey

Between the time that Coronado turned his back in disgust on New Mexico and the time that Oñate showed up full of optimism and replete with colonists, nearly sixty years had passed. During these decades, a few expeditions attempted to enter New Mexico. Most hoped for mineral wealth or souls to convert. One such expedition was led by Francisco Sánchez Chamuscado and accompanied by several priests. While Chamuscado wandered around New Mexico in search of likely prospects for silver and gold, his priests were busy at work trying to convert the populace.

One of these priests, the Franciscan friar Juan de Santa María, was so excited by what he saw on an early expedition into New Mexico that he insisted on returning to Mexico to report. Both his fellow Franciscans and the soldiers tried to dissuade him from this plan, arguing first that his report would be fragmentary and he should wait. When that argument did not work, they tried to persuade him that he might meet his death traveling through the desert alone and that if he did die, the natives would become disillusioned and no longer view the Spaniards as immortal (whether they did seems doubtful in hindsight). Probably attracted by the idea of martyrdom and ignoring the opposition of his fellows, Father Santa María finally won permission from Agustin Rodriguez and left the party on September 7, heading south from the Santa Fe River

Valley through the Galisteo Basin, which at that time was a well-populated area.

The people in the Galisteo Basin watched Fray Juan's progress skeptically. Was he going to get more Spaniards? They clearly remembered the insults of Coronado and his men: shooting their harquebuses, demanding cloth and food and besieging the pueblos. Worse, he might even be in touch with darker forces, with the evil magic of witchcraft, and turn his supernatural powers against their people. If that were the case, they would have to be careful. After deliberations, they set out after him.

Three days into his journey, Fray Juan had walked about thirty miles on his own and might have been justified in feeling like he was going to be safe on his travels. He stopped mid-afternoon in the foothills of the Sierra Morena (now known as the Manzano) Mountains to take a nap. While he was sleeping, some Tiguas from Chílílí or Pa'ako set upon him and crushed him to death (or suffocated him) under large rocks. This particular method of assassination was used primarily to destroy evil spirits, indicating that the pro-witch school of thought had won the day.

Not knowing what happened to their companion, the Spaniards continued their explorations and eventually swung back through the area, where they learned about Fray Juan's murder. The Puebloans tried to keep it a secret from the Spaniards, fearing retaliation. But when Chamuscado learned of the incident, he instructed his men to keep it a secret, for they were still persuading themselves

that they were seen as immortal. Regardless of what the Spaniards believed, the natives were sure the Spaniards could die and were determined to make that happen with all possible haste. Fray Juan's Franciscan brothers, Frays López and Agustin, persuaded the soldiers and the natives alike to stand down because they wanted to remain in New Mexico. If this was because they also longed for martyrdom, the Pueblo of Puaray gave these priests their wish before many years had passed, though without the gruesome witch-killing ritual.

Fray Juan's career in the priesthood was short, and although his career in New Mexico was even shorter, he might have left one permanent mark on the state. In 2010, historian and author Mike Smith was exploring on San Felipe Pueblo land and discovered a signature and three Spanish crosses carved in the rock, apparently by Fray Juan de Santa María. Fray Juan would have passed through the area with the rest of the group shortly before he separated from them forever. Perhaps he had already decided to hasten his martyrdom by leaving the party and wanted to make sure everyone forever would know that he traveled to this wilderness for his faith. Ironically, it could have been the act itself that convinced the watchful natives that he was a witch; ritually creating glyphs was an act of power.

MIRACLES OF THE JUMANO

Although history remembers the Jumano tribe for many reasons, it is less clear exactly who the Jumano were. The tribe seemed to have been very similar to the Tompiro, but while some Jumano lived in pueblos on the edge of the Plains, many lived on the plains of what is now west Texas. For a brief time in the seventeenth century, all Europe was abuzz over the Jumano, and the tribe managed to get military support and other favors, all because of its propensity for miracles.

The story starts in 1612 at Isleta pueblo, where Fray Juan de Salas was stationed as the mission priest. Some Jumano delegates came to Salas and asked him to send priests east to baptize their people. Salas forwarded on their request, but New Mexico had too few priests to mount a potentially dangerous expedition to the Plains at that time.

Years passed until a caravan of priests arrived with astounding news. A nun in Ágreda, Spain, was having visions of the Jumano and was asking that priests be sent to bring them the word of God. When she was not receiving dictation from the Virgin Mary, Sister Maria de Jesús was allegedly astrally traveling to visit tribes in Texas and New Mexico. The new father *custos*, Alonso de Benavides, hastily dispatched Salas and another priest, Fray Diego López.

As they were nearing the country of the Jumano, a group of men approached them, and they shared in mutual astonishment as the priests discovered that the natives had

given up hope of getting baptized, only to be visited by a beautiful blue-robed woman who told them that priests were on the way. They went to see what she was talking about and discovered Salas and López. Salas and López showed them a picture of a nun, and the Jumano confirmed that the woman of their visions was dressed that way. All in all, their mission was a resounding success.

On their triumphant return from the Plains, Salas and López debriefed the father *custos*. Upon his return from New Mexico, Benavides shared this and his other rosy memories of New Mexico, briefly making the Jumano among the most famous tribes in America. Benavides followed up his 1630 memorial with a petition to the king, asking him to subsidize the missions and to support better treatment of the pueblos. Sor Maria was vindicated and soon became venerated as well. Benavides also submitted his memorial on the mission efforts to the pope.

Meanwhile, in New Mexico, the Jumano were experiencing hard times. Conflicts with the Apache had become so intense that the Jumano were cut off from their traditional familial and economic ties. Thanks to the first miracle, they still had a good reputation with the government. In 1650, the Jumano of the Salinas district petitioned Governor Hernando de Ugarte de la Concha for a military escort to visit the Plains Jumano on the "Rio Nueces," now identified as the Conchos, near San Angelo, Texas. Their mission was very successful, not only resulting in peace treaties with the powerful Teyas but also bringing

back a wealth of hides and even some freshwater pearls. Heartened by this success, the government continued regular trade expeditions throughout the decade, until even the military could not provide adequate protection.

Once again, the Jumano were cut off from their Plains relatives. In steadily growing numbers, they found their way down to the mission of Guadalupe del Paso, where they could maintain some kinship ties, especially with groups around La Junta del Rio, where the Pecos River meets the Rio Grande. Some of the first marriages celebrated in El Paso were Jumano refugees, and by the time of the Pueblo Revolt, all the Jumano had left their mesa-top pueblos and migrated south.

When the revolt came, the Jumano were again suffering from cultural isolation but needed an armed escort to reach their kinsmen. They selected a spokesman, named Juan Sabeata, who presented the Spanish with an irresistible argument.

Sabeata offered an enticing list of friendly nations with whom the Jumano had alliances and trade relationships, which impressed interim governor Cruzate. Sabeata also stated that the Jumano had been waiting for ministers since the trade missions way back in the 1650s, which made the father *custos* feel guilty. Then the Jumano offered to provision the expedition, which made all the hungry refugees much more inclined to support his proposal.

Finally, Sabeata brought out the clincher. He showed the Spaniards tattoos on his hands that depicted a colorful

wooden cross, which apparently had fallen from heaven. Priests scrambled all over themselves to be included in the expedition. Perhaps this time, the pope would learn about them! The Plains Jumano welcomed the Spaniards warmly and had even built a church for them to use, but the visit proved to be less than miraculous after all. The Jumano did their business with one another, renewed their ties and parted again. While a briefing was sent along to the viceroy, it is unlikely the pope heard a thing about it. In time, disease and warfare reduced the Jumano to such small numbers that they assimilated into other tribes.

FREEING THE WITCHES

The extent to which the Pueblo people of New Mexico could practice their traditional religion was hotly contested during the first century of colonization. The mission fathers, of course, would have liked to eradicate all traces of what they viewed as heresy. The governors were more or less sympathetic, depending on how much they wanted to fight with the priests. After several of his predecessors had suffered prosecution from the Inquisition, Governor Juan Francisco Treviño was not about to cross the priests. He aggressively prosecuted native religions as witchcraft until he had pushed the Puebloans' patience to the breaking point.

The raids on their *kivas* had started in 1650. Ceremonial chambers had been raided, and the priests burned *fetishes*, masks and other traditional religious goods. This purge had been followed by epidemic sickness, drought and raids by Navajo and Apache warriors. So many livestock died that the Puebloans and the Spanish alike were reduced to eating the leather straps from their carts, boiled with herbs and roots, served up with the ubiquitous corn.

The Pueblos saw this ill fortune as directly connected to the destruction of their ritual goods and rededicated themselves to their ancient ways. The Spanish, immersed in a still-medieval Catholicism, saw the misfortune as a result of witchcraft and knew exactly who to blame. The courts began hearing an alarming number of cases of people, especially priests, who died mysteriously. Contagion and starvation were not considered as factors by anyone involved. The missionary at San Ildefonso began behaving erratically, and sorcery was suspected again.

Governor Treviño came into office as the colonists were becoming increasingly panicked about the ill effects of all this "witchcraft." He decisively moved into action by raiding the Pueblos and arresting their leaders and holy men. He ordered raids and the destruction of *kivas*, as well as whatever sacred objects they found. Treviño's soldiers captured at least forty-seven men and dragged them back to Santa Fe to be prosecuted for "various murders, idolatry and evildoing." Three were hanged, and one

killed himself. The rest were sentenced to public whipping and enslavement on charges of sorcery, particularly for bewitching priests.

Before this sentence was fully carried out, the Pueblos sent large forces of warriors to surround Santa Fe. A group of about seventy heavily armed men managed to slip into the Palace of the Governors undetected and surprised Treviño with beans, chickens, hides and tobacco as ransom for the prisoners. Probably no governor was ever so scared to receive a generous gift, but Treviño summoned up his best paternalistic façade, thanked his "children" and, understanding that his life was at stake, quickly ordered the release of all the surviving prisoners, including a Tewa medicine man named Po-peh.

Treviño suffered through another year of famine, drought and attacks before handing the reins of office over to Antonio de Otermín and clearing out of New Mexico forever. His timing could not have been better. Within a few years, Po-peh had successfully organized and executed a rebellion against the Spanish, driving them from their homes and destroying their churches. As the Spanish tried to discover the causes of the rebellion while huddled in the refugee camp at El Paso del Norte, the story of Governor Treviño and the "witches" emerged as the straw that broke the camel's back.

EXHUMING FRAY GERONIMO

Once the Spanish returned to New Mexico after the Pueblo Revolt, part of the reconstruction effort involved rebuilding churches and other structures that had been destroyed. Another part of reconstruction was helping the Spanish New Mexicans feel pride again after their crushing defeat and exile. Governor Marín del Valle took it upon himself to boost morale in those dark and difficult days. Valle decided that what the demoralized New Mexicans most needed was some real holy relics from some real New Mexican saints. He reviewed the available literature and discovered a couple of possible candidates. One was Fray Geronimo de la Llana, who had served the pueblo of Quarai during the middle of the seventeenth century.

Fray Geronimo arrived in Quarai in 1629 and served his flock faithfully for many decades, much beloved by both the Tiwa and Jumano residents of the pueblo and also by the neighboring Spanish and *mestizo* ranchers. According to a letter that the governor had in his possession, when Fray Geronimo died in 1659, his successor, Fray Nicolás de Freitas, buried him under the chapel in Quarai with a note in his hands. Ten years later (during which time Freitas made as many enemies as Llana had friends), the damp was leaking into Fray Geronimo's grave, so Freitas disinterred the priest from his first burial spot and reinterred him in a drier spot inside Nuestra Señora de la Purisma Concepcíon de Quarai.

After reading all this, Governor del Valle assembled an entourage of dignitaries and rode down to the ruins of the Quarai mission. They entered the crumbled red stone edifice, crossed the dirt chapel floor and started digging at the foot of where the altar once stood. They dug and dug, moved their excavation and dug some more, all to no avail. The furious governor launched an inquiry. By this time, the expedition had attracted quite a peanut gallery, and one of the elderly bystanders was happy to volunteer a suggestion.

He told a story passed down from his father that when the Tiwa of Quarai abandoned their pueblo in 1674, they joined the survivors at nearby Tajique Pueblo. Before they left their home forever, they exhumed Fray Geronimo and carried his corpse with them for the eight-mile walk north. When they arrived at Tajique, they reinterred the priest in the church of San Miguel Tajique. The governor and spectators mounted up and rode to Tajique, where they located the ruined church. This time when they dug, they found what they were looking for—probably. The skeleton's hands held a rosary, not a note, but everyone present accepted the relics as being Fray Geronimo's.

Now Governor Marín del Valle had to prove that Fray Geronimo was worthy of veneration. He solicited testimony from the crowd, and people were happy to comply. One spoke of how Fray Geronimo could rope wild horses with the sash from his priestly robes and tame them with a touch. One told how Fray Geronimo was served "tasty food and drink" by invisible spirits and chastised his flesh by sleeping

with a brick for a pillow. Some of the native spectators claimed that if you saw the ghost of Fray Geronimo three times, you died. One man recalled a story his grandmother had told him about Fray Geronimo curing a pregnant woman's morning sickness by miraculously healing a crippled woman, ordering her to gather lettuce from the garden even though it was winter and then catching a trout out of a stream to finish the salad. All this was enough for Governor del Valle to certify Llana as venerable. With great ceremony, the crowd bundled up Fray Geronimo's bones, and the entire procession rode back to Santa Fe, where the body was sealed in the walls of the adobe chapel of San Francisco de Assisi.

Eventually, the priest's resting place was forgotten, but Fray Geronimo was not to rest in peace forever. The next time his bones were exhumed, New Mexico was an American territory, and a grand cathedral was being built on the site of the old chapel. St. Francis Cathedral had been built around the old chapel of San Francisco, and now it was time to tear the old structure down. Pioneering ethnographer and ethnologist Adolph Bandelier was invited to watch the demolition and was as surprised as anyone when human skeletons tumbled out of the wall! Bandelier discovered a document describing the difficult search for Fray Geronimo and the entire *diligencia* establishing his venerability. Bandelier copied the whole thing out in his diary, although the original was lost soon thereafter.

Fray Geronimo de la Llana was reinterred, this time in the walls of St. Francis Cathedral. Today, you can visit the cathedral and find a small plaque on the wall near La Conquistadora commemorating the good father but failing to describe the many adventures his body had before reaching its final resting place.

A Shield to Her People

The Apaches, far from being a single people with a single purpose, had many different groups throughout the deserts and mountains of the Southwest. The Chiricahua Apaches came into early conflict with the American army, which assassinated their leader, Mangus Colorado, and their sense of honor demanded retribution. A girl named Lozen grew up during this time, when her people would capture Anglos and brutally kill them in payment for massacres of their own women and children.

Lozen turned her back on the frivolous pursuits of the other young women, who spent their time weaving baskets, adorning themselves with fancy bead and shell jewelry and painting their faces with their hallmark vermilion paint. Instead, she played war games with the boys, hurling stones with slings, racing horses and hunting. Apachean cultures had much more gender equality than Anglo cultures of the time, so rather than chastising Lozen, her kinsmen encouraged her and respected her prowess.

The band of Chiricahua Apaches to which Lozen was born lived in southern New Mexico and called themselves the Chihenne, or "Red Paint People." The Americans called them Warm Springs Apaches, after their homeland, which encompassed the geothermal hotbeds in and around the Gila Mountains. When the Americans forced the Native Americans onto reservations, Lozen's brother, Victorio, negotiated the Ojo Caliente reservation in their native Black Range, where many neighboring Mogollones and Mescalero Apaches joined them.

The discovery of gold in the mountains spelled an end to that particular treaty, and the Warm Springs Apaches were summarily removed east to the Tularosa Basin. Disgusted, the Mescalero left and returned to their own lands in the Sacramento Mountains. The Chihenne strongly argued that they needed to be in their homeland and were finally allowed to return to Ojo Caliente.

Chiricahua elsewhere were suffering, and they told the Chihenne of the terrible conditions on the San Carlos reservation in Arizona, where many bands of Apaches had been forced to move. The water was bad, the soil was bad, the agents were corrupt and the place was so infected with evil that it made people sick. On top of that, some military genius relocated the enemy Yavapai there, too, creating a constant undercurrent of intertribal tension. Some of the Chiricahua under Geronimo had decided war was the only response and were actively waging it against any Mexicans or Americans they encountered. The Chihenne at Ojo

Caliente were worried but figured they would be left alone since they had not broken any treaties.

The lure of gold was great, and after hearing ceaseless complaints from prospectors, the orders came down to remove the Warm Springs Apaches from their lands again. This time, they were moved to the dreaded San Carlos, under a policy of "concentrating" the tribes. When the agents came to Ojo Caliente, only about 450 people were there, the remaining 1,500 having formed predatory bands under the leadership of Victorio.

Now in her thirties, Lozen had not married but lived as a warrior. Victorio said of his sister, "Lozen is my right hand…strong as a man, braver than most, and cunning in strategy, Lozen is a shield to her people." Sometimes she served as a literal shield, positioning herself between the soldiers of the U.S. Army and the fleeing women and children. Her favorite technique was to shoot the horses out from under the soldiers and pick them off at leisure as they futilely ran for shelter in the treeless desert.

She also protected her people through her uncanny sense of danger and claimed to be able to feel the presence of enemies, as well as their location and number, through tingling in her arms. Many times, her skill, which the Chihenne believed started at the time of her puberty ritual, saved the Chiricahua with her from ambush. Her people also claimed she had special horse magic, since she could ride and steal horses better than almost anyone. Lozen had another skill critical to a people at war: she was a great

healer and midwife and cared for the pregnant women on the run with them.

Some speculate that Lozen was helping a woman in labor the night that Mexican troops ambushed Victorio's band and so did not undergo the ritual to check for danger. Victorio was killed in that battle after the Apaches' ammunition ran out. Apachean women were not allowed to know the location of graves, so Lozen never learned where her brother was buried.

After Victorio's death, the seventy-four-year-old Nana took over. The Chihenne joined forces with Geronimo's band, as well as other refugees from San Carlos and Mescalero. The Chiricahua zigzagged across the international border, waging relentless guerrilla war against Mexicans and Americans alike.

Lozen battled fiercely to protect her people for four more years. As her people hid in caves or swam across icy rivers to escape angry soldiers on both sides of the border, she continued to summon divine power to sense the presence of enemies. Sometimes the tingling grew so intense that her skin turned purple. In battle, she would herd the women and children to safety and then return to the front lines to fight with the men.

Lozen and Geronimo did not love war, nor could they live with the consequences of such prolonged fighting for their people. Eventually, Lozen and Geronimo's pretty wife, Dahteste, herself a notable warrior, went to the Americans to petition for peace, starting the talks that culminated in

the complete surrender of all the remaining Chiricahua in September 1886.

Along with her people, Lozen was packed on a train and sent to Florida and then Alabama, where she contracted tuberculosis in the swampy climate. Although many of her people were able to return to New Mexico—although not to their homeland in the Gila—Lozen was buried on the prison grounds of Mount Vernon, Alabama, in 1889.

THE REVOLUTIONARY PADRE MARTÍNEZ

Born in the mixed-blood community of Abiquiu under Spanish rule, Father Antonio José Martínez survived revolts, uprisings, rebellions, invasions and schisms with his Mother Church, and he usually took an active role in the events. Throughout it all, he tirelessly fought to preserve New Mexican life ways—particularly religious traditions—while he also tried to "enlighten the mind of my townspeople."

A widower at twenty-five years old, Martínez got to enjoy the last days of the empire and the new days of the republic while studying at the Tridentine Seminary in Durango, Mexico. He must have reveled in the rich atmosphere of the religious and intellectual community because he stayed for six years, while his young daughter was raised up north. The liberal ideologies of Mexico's Republicans, like democracy, education for the poor and civil rights for all, fired up the already passionate Martínez. Upon his

ordination, he moved to Taos and began to practice what he preached.

First, Martínez started a co-ed primary school. While some enthusiastic mission priests offered basic confirmation classes, and some rich people hired private tutors, there had never been anything approximating a public school until Martínez founded one. He also founded the first preparatory school to encourage young men to follow in his footsteps to the Durango seminary.

Martínez saw clearly that in the internal struggles following independence, New Mexico's needs and troubles had become more or less forgotten. For nearly two centuries, the king had subsidized the missions directly and the entire province indirectly. Without his support, the institution of the church—which served as school, hospital, food bank, court and gathering place in many communities—was on the verge of crumbling, and few ordained priests remained in New Mexico.

Stepping up his activities, Martínez acquired the first printing press, originally bought in St. Louis, and started New Mexico's first newspaper, *El Crepúsculo de la Libertad* (*The Dawn of Liberty*), from which he broadcast his moral vision as well as the news of the day. He served as an elected representative in the New Mexico Departmental Assembly, the first of three terms.

He also successfully petitioned the bishop in Durango to organize and protect the confraternity of the Brotherhood of Our Father Jesus. This men's group, popularly called

the Penitente Brotherhood, was sensationalized by the Americans for its rather medieval mortifications of the flesh. But most of the year, the Penitentes were filling the gap left by the departed mission priests. They tended the sick, buried the dead, celebrated the year's holidays and fed the poor. Under Martínez's reforming eye, some acted as educators and community advisors as well.

While Padre Martínez wrought these changes in the sprawling Taos parish, things were also changing farther south. General Santa Anna rose to power in Mexico City and appointed his man, Albino Pérez, who disastrously tried to raise taxes. Some of Martínez's flock rose up in rebellion against the representative of a man Martínez despised for hijacking the ideals of the republic. There is no evidence that Martínez was involved, although rumors flew that he was an instigator. Father Martínez did administer a final confession and the last rites for Governor Gonzales before Manuel Armijo had him executed.

Within the decade, New Mexico had fallen into American hands, and Martínez's flock again rose in rebellion. After General Kearny marched on to conquer California, he left trader Charles Bent in charge as the first American governor. The Taoseños turned on him within the year and massacred the governor and several of his supporters, as well as attacking many other Americans in the area. Martínez maintained a neutral public stance but protested to the American military commander that the due process of the rebels had been violated. Provoked by the Americans blowing holes in the

mission church of San Geronimo de Taos to capture the rebels who had sought asylum there, he transformed his seminary prep school into a law school—another first—to educate the young men of northern New Mexico about their rights under the American government.

During this time, New Mexico got its first bishop, the French missionary Jean-Baptiste Lamy. Lamy had his own ideas for reforming the church. Before long, he came into conflict with the firebrand priest from Taos. Lamy thought Martínez had no business being so active in politics, while Martínez felt that Lamy didn't appreciate how dire conditions were for most New Mexicans. Lamy and Martínez fought over the compensation due to the priests and also fought over the role of the Penitentes, who now included several hundred men, far outnumbering ordained priests.

Ignoring Martínez's pleas, Lamy appointed one of his own men to work in Taos and report on the father's doings. The European-born Father Taladrid was wildly unpopular and solidified support for Martínez, who continued to champion the community-based confraternities, schools and causes for the poor. The more that Lamy and Taladrid tried to disband the Penitentes, the more active Martínez became in their support. Finally, the rift was too deep, and Lamy excommunicated Father Martínez along with his protégé, Father Mariano Lucero.

Neither Martínez nor the people of his parish recognized the bishop's act, and he continued to preach and administer

to the educational, temporal and spiritual needs of his flock, serving them from the chapel in his own house. When Martínez died, mourners at his funeral included over two thousand devoted followers and three hundred Penitentes, about one-sixth of the entire population of Taos County.

Although disliked and disparaged by outsiders, Martínez had devoted most of his long life to making life better for the people of New Mexico, whether Spanish, Indian or somewhere in between. His tombstone, which today lies in Kit Carson Park in Taos, can be translated as "The Honor of His Country," but as a man who lived under three flags, which country? Perhaps a better translation would be "The Honor of His Homeland": not a province, a department or a territory but simply New Mexico.

Part V

STRANGE ALLIANCES

THE TEWA VILLAGE IN HOPI

Heady feelings of triumph for the people of the central New Mexico pueblos didn't last long after the Pueblo Revolt of 1680. Governor Otermín's attempted return reminded the Puebloans that the Spanish would eventually return, and remembering how they seemed to stand in the path of any conquering army, they decided to relocate. When the Spanish did return, many more relocated, and after the failed revolt in 1696, many pueblos were abandoned entirely, out of fear of retribution. Some of these refugees found a home on the Hopi First Mesa.

According to Hopi legend, the Tewa sent a delegation offering to help them fight the Navajo in return for land. According to Tewa oral history, the Hopis came begging for the skillful Tewa warriors to protect them. Either way, a couple of thousand men, women and children from Santo Domingo, Alameda, Jemez and Puaray (which Otermín had burned to the ground) packed up and moved to the First Mesa. There, the refugees established a village where they could follow their traditional ways; from there, they did indeed acquit themselves bravely in battle against the Navajo and Ute raiders.

To outsiders, there may not be fine distinctions between the Hopi culture and that of the Rio Grande Pueblos, but both guests and hosts felt the difference. One of the glaring problems was language: the Hopi language is from an

entirely different family, Shoshonean, than the languages of the Tewa and Tano.

Again, the Tewa and the Hopi have different tales explaining what happened when the Tewa arrived. The Tewa recall that the Hopi treated them rudely at first, and so their clan chiefs dug a pit between Hano and the next Hopi village and made the Hopi clan chiefs spit into it. Then the Tewas covered the Hopi spittle with their own, covered the hold and announced that they had sealed "knowledge of our language and our way of life from you. You and your descendants will never learn our language and our ceremonies, but we will learn yours. We will ridicule you both in your language and our own."

The Hopi tell the story differently, claiming that the Tewa allowed their hosts from Walpi (another town on the First Mesa) to spit in their mouths to teach them to speak Hopi. When the Tewa offered to return the favor, the Walpi rejected the offer with disgust, claiming it would make them vomit, which may not have been hyperbole.

As uncomfortable as the refugees were at Hopi, they were relieved to be living in a traditional pueblo far from Spanish influence. After the Reconquest in 1691, they hoped to continue evading the meddling of the priests, but it was not to be. Fray Juan Miguel Menchero, who came to New Mexico as the "Delegate and Missionary and Commissary General of this Holy Custodio of the Conversion of Saint Paul" in 1731, was tireless in his efforts to reestablish the Catholic mission as central to indigenous

New Mexican communities. His first task was settling the Picuris, who would flee to the Jicarilla Apache at the slightest provocation. He turned west and convinced the Navajo, by means of very lavish gifts, to accept Christianity and settle down, which they did, at least until the flow of gifts stopped coming. According to his own reports, he reestablished "friendly" relations and missions at Acoma, Laguna and Zia.

Finally, Father Menchero turned his sights to recovering the refugees who had fled west. In 1742, he sent priests out to "the apostate nation of Moqui," and they brought back several hundred people willing to resettle at Jemez and Isleta. Menchero agonized over how to get more of the Pueblos back in the mission fold and determined to rebuild near the new villa of Albuquerque. He picked out a nice spot and gave it the sonorous name of Nuestra Senora de Dolores de San Antonio de Sandia. He submitted his paperwork, grinding into gear the slow wheels of the complex Spanish bureaucracy. He returned to the Hopi again in 1745 and collected several hundred more Tewa willing to resettle Isleta and Jemez, but those pueblos were reaching their capacity.

By 1747, the petition to resettle Sandia had borne fruit, and the viceroy sent the order to gather families for the new mission community. Menchero gathered enough soldiers to back him up and headed west again. But this time, the people who wanted to leave had already left; the people remaining really wanted to stay. Fray Juan probably first

tried rhetoric to convince them to return. Before long, the negotiations degenerated into fighting. To their credit, the Hopi put aside their differences and fought alongside their neighbors. Menchero's men killed eight people and destroyed the fields on the First Mesa. Ultimately, he was able to move fifty families from the First Mesa to the new Sandia Pueblo, which Governor Joaquin Codallos y Rabal formalized within the year.

Those who managed to stay on the First Mesa eventually built the village of Hano, where they still live. The people of Hano remained distinct from the Hopi for about two centuries, but recent generations have begun to intermarry so that about half the people of Hano have Hopi spouses. The events of their first tumultuous days have continued to color the present: it is true that to this day, the people of Hano are the only ones who speak Tewa and Hopi, and Hopi men who marry into the matrilineal clans of Hano never learn the language.

A French New Mexican Trailblazer

Born in Lyons, France, Pierre Vial found his way to the New World, seeking fame and fortune like many young men of Europe. While he found neither, he did make his way into the history books as the man who blazed a route between the remote royal colonies of Santa Fe and San Antonio. Details of his early years are hazy, but he seems

to have trapped along the Mississippi before reaching New Orleans and, from there, the lively border town of Natchitoches, just across the border of New Spain. When France handed Louisiana over to Spain in 1762, he chose to cast his lot with the Spanish and soon became known as "Pedro" Vial.

The Spanish and French had been at loggerheads for generations, but they had common cause in their dislike of the British and their alarm about the American rebels. As one French Indian agent wrote to the viceroy of New Spain, although they had been foes in the past, now they could unite to protect their common borders against these "active, industrious, and aggressive people." Speaking from experience, the agent continued that if the Americans were left unchecked, they would extend their economic reach into the unsettled area between their frontier (still safely east of the Appalachians) and the Spanish frontier. Once they established trade, forts would follow, and settlers, until "they will have become irresistible."

In the previous decades, Spain had established *presidios* along its northern border with French Louisiana. The Presidio of San Antonio de Bexar was the foremost, and the commander of San Antonio also served as regional governor. From there, other forts like the Presidio of San Saba were constructed and garrisoned. But after raiders burned down the mission of San Saba (probably egged on by the French), it became painfully clear that these tiny

outposts could not be expected to hold the frontier. The obvious thing to do was to establish intercourse with the comparatively large and thriving colony in New Mexico and work together with the soldiers in Santa Fe. The only problem was that nobody knew exactly how far away Santa Fe was or how to get there.

Pedro Vial was in San Antonio when the governor approached him about finding a route. Vial had traded with the Taoveyas (sometimes identified as Jumano), who lived around the grasslands of what is now the Texas-Oklahoma border. He felt confident that they could steer him in the right direction and set out with a party of exactly one other person, Cristóbal de los Santos.

Considering that Spanish governors had arrested Frenchmen like Vial only a few decades prior to this assignment, it is ironic that the Spanish would trust a foreigner to explore their country and to represent them on such an important mission. But the French had much better relations with the Plains tribes, not bringing them much of an agenda besides mutual profit. Vial had explicit directions to explain to all the tribes he met that the Spanish and French were friends now, so there was going to be no more ganging up on the Spanish.

Indeed, when Vial arrived at the pueblo of the Taovaya, the people were quite happy to see him and sent him onward with six Comanche guides. They took him to the Comanche chief Zoquiné, who was genuinely delighted with Vial's presence in his home and tried to persuade him

to stay the winter. But by March, Vial was ready to move on, so the chief and some of his people determined to travel with them. En route, they met some other Comanche, who were convinced that Vial was bringing orders to commit genocide on their people. Chief Zoquiné persuaded them that their mission was peaceful, and after two weeks of negotiating, they moved on, only veering off path to go hunting, to pay some visits or because they got a little lost.

Seven months after his departure from San Antonio, Vial arrived in Santa Fe after traveling over 1,100 miles. The New Mexican governor, Fernando de la Concha, was tremendously excited and immediately sent one of his own men to test Vial's route. José Mares and de Santos, who wanted to go home, didn't take so many scenic detours, and Mares carved the route down to about 700 miles. Now the whole frontier was buzzing about the possibilities of friendlier relations with the Plains tribes, communication among the miserably isolated colonists and perhaps even expanding their reach farther north and farther east. But they still wanted the French trader to pave the way for them. Governor Concha decided that Vial would blaze a new trail, from Santa Fe to Natchitoches, from there to San Antonio and then returning to Santa Fe to report.

This time, a slightly larger party accompanied Vial, and he led them confidently across the featureless Llano Estacado, visiting with all the Comanche they met. The former terrors of Spanish New Mexico welcomed the wandering Frenchman with open arms and assured

him he was on the right path. He continued on to enjoy a stay with the Jumano, then more Comanche *rancherías*. Wherever Vial traveled, he was welcomed as a friend, and the Indians not only allowed him to pass unmolested but often accompanied his party as well. Even a barbarous Englishman entertained them one night, although "we could not understand his conversation," noted Vial's scribe.

Vial reached Natchitoches in about two months and San Antonio in another three months, without any catastrophes besides catching a nasty cold. He rested in San Antonio until early summer and then returned to Santa Fe, this time reaching it in two months flat, again without incident. The road between the two capitals was open, and commerce between the towns began right away.

Historians note that Vial's greatest accomplishment was establishing a trail from Santa Fe to St. Louis, which would become the Santa Fe Trail thirty years later. But the road between Santa Fe and San Antonio was used right away and changed the sense, for both New Mexicans and Texans, that they were alone in the world.

Under Mexican rule, relations with the Plains tribes deteriorated enough to make travel between Santa Fe and San Antonio dangerous and unpleasant. Relations between New Mexicans and Texans also fell apart during this time, and Texans found on the road from San Antonio were captured and imprisoned. The Americans invaded, just as the French Indian agent had prophesied. Before long, everything was different, except that Vial's route

remains the best way to travel between Santa Fe and San Antonio, as well as Santa Fe and Natchitoches. Today, a highway system traces the trails he blazed in the last days of the eighteenth century.

LAGUNA FETISHES FIND A NEW HOME

In the centuries following the Pueblos' revolt against church authority, the people of Laguna and the Catholic Church achieved a kind of equilibrium, but the arrival of the Protestant Americans changed the dynamics of the religious tensions in New Mexico. When Presbyterians began converting the Laguna people, the traditional Catholics smuggled out Laguna's most sacred objects and removed them to Isleta, where they would be out of harm's way.

For centuries, the Pueblos had worked hard to maintain their religious traditions while practicing a passable Catholicism. As one Laguna elder, Mrs. Walter Marmon, said when asked about her parents' religion, "They were baptized in the Catholic Church...I guess in the Keresan group as they said. Not so much Catholic, but they had their Indian part of it." But soon, conservative Lagunas began feeling their heritage—both Catholic and Pueblo—under attack.

The "attack" was actually the well-intentioned efforts of Presbyterian missionaries Walter and Robert Marmon. The Indian Bureau appointed Walter Marmon as the

first teacher in the pueblo, and after he married a Laguna woman, his brother and cousins soon followed, along with his friend George Pratt, who all married into the pueblo and gained political influence.

Soon, many Laguna people had become Protestant and were disavowing both their Catholic faith and their traditional religion as superstitious idolatry. A rumor spread that the Protestants, led by Robert Marmon, were agitating to wreak some havoc and destroy the "idols" of the Pueblos. The traditionalists plotted in secret to preserve their tribe's sacred objects.

One group gathered their sacred paraphernalia, including the Corn Mother *fetishes* that each tribal member kept. The Corn Mothers were perfect cobs of corn that were wrapped with wool and feathers. They also gathered masks and other objects used in their rites. Carrying these goods, a coalition left the pueblo and crossed the Rio Puerco to enter Isleta Pueblo. The Isleta at first did not welcome the Lagunas, so the dispirited refugees turned north to go to Sandia.

Before they had gone far, a group of Isleta rode up and entreated them to come back. The Isleta council had decided that having more Corn Mothers would be good for the pueblo and promised to help them keep their goods safe. The Laguna refugees stayed, intermarried with the Isleta and assimilated.

A small group stayed at Laguna, braced for the inevitable. Before long, a mob assembled and tore up two *kivas* but

found none of the ritual goods they had hoped to destroy. In a frenzy of self-righteousness, the zealous converts marched on the St. Joseph mission church, determined to tear it to the ground as well.

One of the conservative traditional shamans stood at the door of the church. He entreated his people to stand down, and they relented. The church was saved, but the traditionalists knew they were still threatened.

Within a few years, another Presbyterian, John Menaul, arrived in the community with his fervid missionary wife and set about transforming the educational system. Menaul even translated a Catechism and a *McGuffey's Reader* into the Laguna language. Through his school, the Protestant factions gained many more converts, especially among the young. Eventually, the Catholic and Pueblo traditionalists had enough dissent and founded their own community of Mesita. When they left Laguna Pueblo, they carried the saint from the church, as well as their kachina masks.

ACOMA'S JEWISH GOVERNOR

As a young boy growing up in what is now Dortmund, Germany, little Solomon Bibo could never have imagined that the strange path of his life would lead him to become the first and only Jewish governor of an American Indian nation.

The Bibo brothers—Emil, Joseph, Leopold, Nathan, Simon and Solomon—were driven from their native Germany by a mid-century upwelling of reactionary nationalism. In America, they were drawn to New Mexico by the Spiegelberg family, whose patriarch had marched on New Mexico with General Kearny and found it a good place for business. After working for the Spiegelbergs for a few years, the Bibo brothers launched their own business: the Bernalillo Mercantile Company.

The brothers spread out, establishing branches of their mercantile in Bernalillo and parts west, including Laguna, Seboyeta (Cebolleta), Cubero, Grants and Fort Wingate. Solomon, who had followed his brothers to America in 1869 and to New Mexico shortly thereafter, ran the store at Cubero and got to know the people of Acoma Pueblo, as well as their Laguna neighbors, who were at loggerheads over the disposition of the land that lay between their pueblos. The Lagunas were egged on by the Marmons, government surveyors and Presbyterian missionaries who had married Pueblo women.

Solomon was a gifted linguist and quickly learned to speak the western Keres dialects of his customers, as well as the very different languages of Zuni and Navajo. He spoke Spanish with the nearby ranchers and farmers of communities like San Mateo and English with the American soldiers of Fort Wingate. When he was with his brothers, they reverted to the comforting German and Yiddish of his youth.

He put his abilities to work on behalf of the Acoma and wrote letters in 1876 and 1877 to support their claim on the disputed land, but the land office granted the patent to Laguna anyway. The loss rankled for the Acoma, but they appreciated Bibo's help. On his side, he saw an opportunity to convince the Acoma to let him open their first trading post. Brothers Emil and Leopold took over from Solomon at Cubero, and in 1882, he opened a store on the very top of the legendary Acoma mesa.

Within a few years, he fell in love with and married a sweet-tempered Acoma woman named Juana Valle. Without a rabbi, the couple celebrated an Indian marriage with a Catholic priest and a civil marriage before a judge. By all accounts, Juana and Solomon had a very happy and long marriage, despite their cultural differences. The placid Juana was an excellent counterweight for her energetic husband, and one friend described their marriage as "so beautiful an example and so rare an inspiration."

The land disputes with the Lagunas continued to simmer, and Bibo had certainly taken sides. He confronted the Laguna and asked them to return some land but was rebuffed. Together with his in-laws, Solomon Bibo cooked up a scheme to lease a substantial part of the Acoma grant, creating an arrangement that not only shut out the Marmons but also retained the grazing and water rights on the land for the Acomans.

The Lagunas pressured the Indian agent, Pedro Sanchez, to bring charges against Solomon Bibo, which he did.

Sanchez also pressured the Acoman governor to publicly recant the terms of the lease with the merchant. Bibo, his brothers and his extended Acoman family presented a spirited defense, and the letters flew back and forth across the country as each side escalated the rhetoric. At the height of the battle, when Solomon's trading license had been yanked and he was refusing to abandon his trading post, events took a strange turn.

The Acomans elected Solomon Bibo governor, the first and only non-Indian ever to serve in such a capacity for any of the pueblos. Sanchez lost his job as Indian agent. Although his successor ended up denying his lease, the Marmons didn't get it, either. Bibo and his family must have felt considerable schadenfreude.

Unfortunately, Bibo didn't make a good governor for his adoptive people. The traditional Acomans resisted his reforms, which included establishing new communities near the newly built railroad and sending the children to school, the first of which was in his house. The progressive Bibo continued to battle traditionalists after he was out of office, and eventually the family felt so uncomfortable that they moved away from Acoma to the village of San Rafael, near Grants, and then, by 1899, on to San Francisco, where they added two sons to their brood of four girls.

In San Francisco, the family became active members of Temple Emanu-El. Juana and Solomon celebrated the bar mitzvah of Leroy in 1912 and that of Carl in 1924. Leroy also participated in the traditional male coming-of-

age rituals of the Acoma. The happy times came to an end with the Depression, when one disaster after another hit the family's finances, including the loss of their Acoman grazing rights followed by the loss of about twenty thousand sheep. Despite these hardships, Solomon and Juana remained happily in love. Juana converted to Judaism, and they are interred together at Emanu-El's Home of Peace Mausoleum in California.

Many of their children returned to New Mexico, and their descendants live here to this day. Bibo family members continued running businesses along Route 66 throughout the twentieth century. As for the land disputes with the Laguna, a 1933 agreement returned nearly 4,400 acres to Acoma. The Acomans repurchased the Bibo Ranch in 1997, and Marie Bibo, whose husband, Phil, ran the Los Cerritos store on Route 66, donated the remaining family land to the pueblo in 1998.

FDR and the Curanderas

New Mexico was largely without doctors for much of its history, and rural communities were especially reliant on the community *parteras*—midwives—who were often also *curanderas* (herbalists). Some American doctors trickled in, mostly attached to the army, but New Mexican women continued to turn to the *curandera-parteras* in their times of need.

Even where there was a rare community doctor, most New Mexican villagers preferred to refer matters to their local *curandera-partera*. An observer in 1936 commented, "The midwives were very important people in their villages, and they helped with many other things besides births. Lots of places they were called *médicas*." She added that they often "dispensed herbs for different complaints and also played the part of a counselor for villagers."

Unlike formally trained doctors, the women would accept food or labor as payment and never charged as much. For the women, the position offered a rare opportunity for economic independence and respect, well worth the odd hours and hard work.

A *partera* had two helpers: a *tenedor*, usually a man who could physically support the laboring woman, and her assistant, who was handpicked for her courage and intelligence. Most *curandera-parteras* chose successors whose children were grown, but some precocious girls like Jesusita Aragón, who delivered over twelve thousand babies in her lifetime, were recruited as young as thirteen. While she was important, the *partera* could also be a frightening figure. Elderly women interviewed as part of the New Deal's WPA writing project talked about these healers as "witch nurses."

Superstition and spirituality certainly played as much of a role in early midwifery as medicine did. Difficult labors were considered punishment for sins by the parents. *Parteras* invoked the help of San Ramón Nonato, who was believed to help midwives because his own mother died in

childbirth. New mothers were encouraged to avoid eating chili and to keep the child out of bright light. Many were restricted to a diet of lamb and blue corn *atole* for forty days. That *parteras* were not considered doctors is clear from the wording in the Territorial Practices Act of 1912, which exempted midwifes from prosecution under the Practice of Medicine Act.

Despite the interventions of San Ramón, such as they were, New Mexico still had the highest infant mortality rate in the nation. Malnutrition and poor sanitation were primary culprits, and there was only one person in the remote rural villages who could remedy that. When New Mexico finally achieved statehood and organized a public health department, standardizing midwifery became a primary concern. Starting in 1919, the state began regulating and certifying the *curandera-parteras*. Classes taught the women about hygiene and the best practices for complex deliveries. The previously isolated women also met one another and shared information.

The success of these programs, which trained and certified hundreds of rural women, is perhaps what convinced administrators of the New Deal Rural Health Program to continue training and employing the *curandera-parteras* after the Farm Service Administration (FSA) was established in 1937. The FSA specifically required a doctor to attend births but bent the rules for New Mexico's *curandera-parteras*. Instead, the *partera* training programs intensified, enrolling over 1,400 women in 1938. Despite

rural New Mexicans' distrust of federal intervention (the WPA was often referred to as *El diablo a pie*, or "the devil on foot"), the stamp of approval helped the community midwives achieve legitimacy and recognition, no longer confused with *brujas* (witches).

As mortality rates fell, the success of the program was evident. Unfortunately, the FSA's Rural Health program fell apart after the start of World War II. Seeing a need to continue training *médicas* as community healthcare providers, Catholic University in Washington, D.C., established the nation's first clinical midwifery school and birth center in 1944. Modern midwives continue to support New Mexican women's health using traditional wellness techniques, natural remedies and a balance of spirituality and clinical medicine. In 2011, New Mexico still leads the nation in midwife-assisted births.

Part VI

LIFE DURING WARTIME

DEFENSE AGAINST THE COMANCHES

Juan Bautista de Anza realized when he became governor in 1778 that New Mexicans were totally demoralized after nearly a century of Comanche attacks. Governor de Anza decided a strong defense might be an effective approach and issued new building codes so settlers could more effectively protect themselves and one another during raids. Like previous efforts to regulate or tax the citizens of New Mexico, this was doomed to failure from the start.

As the United States of America established its independence, New Mexicans were oblivious to the fracas far to the east; they had their own problems. New Mexicans suffered from poverty, epidemic disease and endless, terrifying raids from surrounding tribes. The Comanche were particularly troublesome, having established a healthy trade in guns with the French over the course of the eighteenth century. They turned these guns on Pueblos and Spaniards alike, as well as all the southern Plains Apaches. They even turned against their former allies, the Utes, who begged the Spanish for protection.

A near-constant state of warfare lasted throughout these troubled times. Sometimes the Comanche came peacefully to Taos to trade, but these visits were fewer and farther between. During one visit, some Comanche were infuriated to see the people of Taos Pueblo dancing with two dozen Comanche scalps. They gathered a huge war party and descended on the Taos Valley one August night

in 1760. The families who lived along the river gathered together in the house of the Villalpandos, who had a large fortified tower. The Comanche gathered under the tower and fired burning arrows into the loopholes, setting the whole structure ablaze. When the defenders climbed the parapet to put out the fire, the Comanche picked them off and captured all sixty-four of the surviving citizens.

The Comanches got banned from the Taos trade fairs but otherwise escaped punishment. The next administrator, Governor Cachupin, earned the respect of the Comanches, and hostilities ceased for a while under his tenure. A military review completed during this time makes little note of the threat from the Comanche. But as soon as Cachupin left office, the warrior tribe conducted vicious raids with renewed vigor. Governor Mendinueta tried aggressively attacking the Comanche, which seemed to make things worse. He switched tactics and tried to negotiate with the raiders, inviting them back to the trade fairs, but that didn't have much lasting effect either. More alarming, Mendinueta discovered that enterprising embezzlers were stealing armaments and powder from his own royal armory to sell to the Comanche. After a few years, he was quite happy to resign and hand his office over to whoever would take it.

Juan Bautista de Anza came into office having served as the governor of Sonora and been celebrated as the hero who forged a trail between the *Pimería Alta* (around Tucson) and the California missions. He found New Mexico paralyzed,

with never enough men, guns or horses to defend the province. Before mounting expensive expeditions against the Comanche, he wanted New Mexicans to try a little harder to defend themselves. Anza's personal Corps of Engineers, a mathematician, cartographer and engineer named Don Bernardo Miera y Pacheco, recorded his order on a 1779 map:

> *At present, the settlements in the province are very poorly arranged, with the houses of neighbors dispersed, isolated from each other, and this arrangement is so bad in which they have situated themselves, each individual on a piece of land granted for his own house, considerable damage, disaster and desolation has been brought to the settlements because of the enemy Cumanchis and Apaches that surround this Province killing and abducting many families.*
>
> *This order must be executed with exactitude and prompt obedience and with all prudence, charity and zeal for the royal service, according to the word of our Lord Governor, who after viewing these towns, issues this order to remedy this disorder, and to maintain stability, civilization, and a Christian polity, for the settlements to build ample square plazas of at least twenty families each in the form of redoubts, the small ones with two bulwarks and the large with four, between the ramparts, for the range of the small firelocks that are now in use.*

In case anyone had forgotten the horrors of Villalpandos, Miera reminded the reader, "These shall not be made like the large towers in the old style, under which the enemy can find cover set them afire, as has happened before."

Miera continued by pointing out the architectural advantages of the Pueblos:

> *The Pueblos of Christian Indians, remain united as a politic and civilized people, as when the Spanish first found the pagans, in their houses of two and three stories joined together, all with portable ladders, which they draw up when threatened, and the roofs and high and low terraces, with embrasures in the parapets for defense from the enemy and offense against him.*

The *bando* was read everywhere in New Mexico. Settlers in both Albuquerque and Taos, as well as a few scattered Spanish villages, agreed to rebuild according to this plan, although they never made much progress beyond good intentions. The residents of the two oldest villas, of Santa Fe and Santa Cruz de la Cañada, were stubbornly opposed to remodeling their towns. They were particularly indignant about Anza's proposed plan to relocate the Santa Fe *genízaros* to the frontier, raze the *barrio* of Analco (south of the Santa Fe River) where they lived and build in its place a real *presidio*. The recently appointed commandant general of the *Provincias Internas* (consisting of all the territory from Texas to Arizona)

was suddenly faced with a barrage of complaints from mutinous citizens and asked Anza to back off.

Commandant General Croix was not unsympathetic to Anza's plight, and since New Mexicans refused to comply with defensive building codes, Croix helped Anza defend his borders the old-fashioned way. Anza raised an army of nearly six hundred Spanish soldiers (many Ute and Apache joined later, happy to take revenge for all they had suffered) and, with this overpowering force, rode on the Comanche and battled them until they agreed to peace. Croix also helped Anza with the funds to provide the pacified Comanche with seeds, tools and other peacetime technology in the form of annual gifts. Although the Comanche didn't take to agriculture or settlement, they did keep the peace until the Mexican government, breaking with Spain and all its policies, stopped honoring treaties with the Comanche.

DUCKING A HAIL OF BULLETS

The brutal Siege of Veracruz lasted twenty days, the longest battle of the Mexican-American War. In contrast, the Battle of El Brazito was the shortest, lasting merely twenty minutes to half an hour. As brief as it was, the quiet campsite of Brazito on the Rio Grande saw the only pitched battle the Americans encountered during their invasion of New Mexico.

On Christmas Day 1856, Colonel Alexander Doniphan was marching on El Paso with the First Regiment Mounted Missouri Volunteers. They were feeling happy and confident after their bloodless occupation of Santa Fe and the weeks of balls and parties that had followed. The regiment stopped at the old *paraje* of Brazito, at a bend of the Rio Grande, to picket their horses and get comfortable for the night. As they relaxed after their day's march, singing "Yankee Doodle" and "Hail Columbia" and firing their guns in celebration, scouts reported the approach of hundreds of Mexican troops dragging a howitzer with them.

Colonel Doniphan quickly got his men in formation, ordering them to hold their lines. The Mexicans, bearing a black flag with a skull and crossbones and the legend *Libertad O Muerto*, approached and demanded that Doniphan appear before their commander, General Antonio Ponce de Léon. Doniphan declined, and the Mexican messenger responded, "Curses be upon you—prepare then for a charge—we neither ask nor give quarter." He rode back, and the Mexican troops began advancing on the Americans, hampered by the dense undergrowth.

The Americans waited patiently as the Mexicans advanced, firing as they came. The Mexican soldiers at the time were equipped with rifles that fired once and then needed a rather long pause to reload. Ponce de Léon's soldiers were also trained to fire simultaneously, so all their bullets flew at once. Doniphan watched carefully to see how far the bullets would fly and how long it took

the Mexicans to reload. When the Mexicans came within rifle range, Doniphan shouted to his men to "lie down on their faces, and reserve their fire until the Mexicans came within 60 paces."

The Americans, understanding their commander's strategy, threw themselves on the ground as the entire Mexican regiment fired at once, so the bullets whistled harmlessly over their heads. Believing they had slaughtered their foes, the Mexicans started to congratulate one another on wiping out the Yankee invaders so efficiently. As they paused, the American soldiers hopped up and rushed the Mexican ranks, each one shooting and slashing in a way that the well-drilled Mexicans didn't appreciate.

The confusion this created was considerable, and some of the Mexican soldiers actually retreated toward the Americans. The Americans quickly captured the howitzer, and as they turned it to fire into the Mexican ranks, they discovered that their opponent's army was in full retreat, abandoning supply wagons filled with food and El Paso wines.

The Missouri volunteers had wounded General Ponce de Léon, captured the flag and sustained minor wounds and no fatalities on their side. They buried the seventy-one Mexican dead, secured their five prisoners and returned to their camp to break open the fine El Paso wines and celebrate with a captured Christmas feast.

SAVING WHISKEY FROM THE REBELS

In July 1861, Major Isaac Lynde of the Seventh Infantry was terribly worried by rumors of Confederate troops moving into New Mexico. The Seventh Infantry was charged with the defense of Fort Fillmore. Fort Fillmore lay close to Mesilla, the newly declared capital of the Confederate Territory of Arizona. Although Lynde had 410 men and officers under his command, he didn't feel confident of their ability to defend the fort, much less the Union.

The rumors were confirmed when the Second Texas Mounted Rifles marched on Mesilla and Lynde at first allowed them to pass without resistance. Something changed Lynde's mind, and he rode against Mesilla with nearly all 410 men of the Seventh Infantry. Cautiously approaching town, they skirmished with a few Texans. The Union artillery was so pathetic that the Mesillans stood on their roofs and mocked them. After three of his men were killed and seven wounded, Lynde ordered a retreat to Fort Fillmore.

He spent two days fretting over his situation. The Battle of Mesilla, such as it was, had undermined Lynde's faith in his forces. He ordered his men to fortify their defenses, then changed his mind and ordered an evacuation of the fort. The Seventh Infantry would move to Fort Stanton, and it would destroy whatever it could not carry with it to prevent the fort from falling into enemy hands. Lynde might have been worried about disloyalty, since he hadn't

paid his troops in ten months, but it turned out he had bigger problems on his hands.

The men set to work methodically at first, smashing and burning anything that wasn't portable. The men detailed to destroying the infirmary stores discovered casks of medicinal whiskey, believed to be useful in treating rattlesnake bites. They decided that there was no fate worse than letting good liquor fall into the hands of the invaders and set to work "destroying" it, one cup at a time. Word spread of the "destruction" of the ample stores of liquor, and the men set to work with a will. When the orders came to march at 1:00 a.m., the troops filled their canteens with the remaining whiskey and set off on the 140-mile trek across the desert to Fort Stanton.

Every New Mexican child knows that you need a minimum of one gallon of water—no substitutes—per person per day, and more in the summer. Somehow, after at least a year in New Mexico, these soldiers forgot this, forgetting as well that alcohol has a powerfully dehydrating effect. July 27 dawned typically hot and sunny, and before they had marched ten miles from Fort Fillmore, the Union soldiers began collapsing from drunkenness, dehydration and exhaustion.

When the Texas Mounted Rifles rode up in pursuit, they picked up severely inebriated and hungover soldiers across a five-mile stretch of trail. The ones not passed out were piteously begging for water. One Confederate soldier, recalling the scene of disarray along the trail, wrote, "We

found some of the guns loaded with whisky and a good portion of the soldiers drunk and begging for water."

Major Lynde rode at the sober head of the column with the women, children and officers. When the Confederates arrived, he surrendered unconditionally, asking only that his officers and their wives be "protected from insult." His forces were nearly triple those of the Confederates but could barely stand. His weapons were considerably superior, but hardly anyone could shoot straight at that point of the day. His officers (who had not been invited to the whiskey-destroying party the night before) vociferously protested the surrender, but Lynde was adamant.

The Confederates paroled most of their four-hundred-plus prisoners, took what they needed and destroyed the rest. Fort Stanton fell quickly without support from Lynde's infantry. For the intemperate soldiers who were captured, their night of debauchery was the last fun they would have. After spending two days recovering from their hangovers, they were marched to Fort Leavenworth, many of them becoming deranged from dehydration en route.

Furious at their loss, Fort Fillmore's officers wrote to the secretary of war as soon as they could reach Albuquerque in August. The assistant surgeon wrote:

> *I am unable to express to you the deep grief, mortification, and pain I, with the other officers, have endured from this cowardly surrender of a brave and true command to an inferior force of the enemy,*

without having one word to say or firing a single shot. I, among other officers, entered my solemn protest against the surrender, but we were peremptorily told by Major Lynde that he was the commanding officer. To see old soldiers and strong men weep like children, men who had faced the battle's storm in the Mexican war, is a sight that I hope I may never again be present at. A braver or truer command could not be found than that which has in this case been made the victim of cowardice and imbecility.

Some historians have alleged that part of the surgeon's indignation stemmed from his laxity in allowing his medical stores to have been consumed by the enlisted men, a fact omitted from his congressional testimony, though he confirmed the total destruction of all the fort's whiskey, rum and wine. Lieutenant Colonel Baylor was politely silent on the state of the men he captured that day. This official inquiry into Fort Fillmore's loss resulted in Major Lynde being stripped of his commission and dishonorably discharged from the army. No other officers were charged. His rank and retirement benefits were restored after the conclusion of the Civil War, but the shame of his surrender haunted him his whole life.

THE FEMALE BUFFALO SOLDIER

Life for freed slave Cathay Williams was so hard that she disguised herself as a man and enlisted in the U.S. Army, hoping that she could find steady employment serving on the wild New Mexican frontier. Cathay Williams grew up as a house slave around Independence and later near Jefferson City, Missouri. When the Civil War broke out, some Union soldiers captured her and made her travel with them as a cook. After traveling around the South with the army, she even served as cook and washerwoman for General Sheridan.

Maybe Cathay liked the military life, or maybe she was just too independent to rely on someone else to support her. Either way, in 1866, she enlisted as an infantry soldier along with a male cousin. She put an "X" next to her new name, William Cathay. She evidently managed to evade a thorough physical; the doctor signed off on her enlistment form where it states, "I have absolutely inspected the Recruit, William Cathay previous to his enlistment." Apparently, she checked out as sober, of lawful age and duly qualified to serve as an able-bodied soldier, for in no time she was wearing the red Zouave uniform of the Thirty-eighth Infantry. Cathay's regiment was full of freed slaves who had found little opportunity with their freedom and were ready to try their chances with the army.

The Thirty-eighth organized near Jefferson City but soon marched for New Mexico. Footsore from the unbelievably

long walk from Missouri to southern New Mexico, Cathay found herself at her new home: Fort Cummings, sited at a rare spring in the barren Chihuahuan Desert. Fort Cummings was an awful post. The weather was alternately baking hot and bitterly cold, and the buildings provided inadequate protection from the elements. Frontier military officers were often brutal to the enlisted men, whipping them and striking them with swords. Worst of all, many of the citizens were Confederate sympathizers and resented being protected by freed slaves.

Raiding Indians, mostly Apache, were a terrible threat to the men (and the woman) at Fort Cummings. It was built in the middle of *Apachería* and often fell under attack. Though the fort was walled, soldiers were threatened every time they left the protected area to find wood. The infantry was particularly vulnerable to the expertly mounted warriors.

The cavalry regiments got most of the glory in those days, riding out in retribution for attacks and valiantly engaging the enemy. The infantry, particularly the African American troops, got stuck doing all the menial labor necessary in a fort, from digging latrines to building structures, leveling roads, cooking, carpentry and hauling water and wood. At one point, the Buffalo Soldiers (a name given to the African American cavalry) at Fort Cummings mutinied against the white officers due to repeated injustices. Although William Cathay is never mentioned by name (nor ever prosecuted), presumably she participated as well.

Many of the soldiers were also subject to virulent gastrointestinal diseases thanks to contaminated water and a bad diet. Alcoholism was rampant, along with its attendant ills. Infections, injuries, hard work and stress weighed heavily on Cathay. She was sick more and more often and was admitted to the hospital five times, for "itch," rheumatism, neuralgia and unspecified sicknesses, lasting two weeks at a time. How any doctor failed to notice she was female remains a mystery.

In an interview with the *St. Louis Daily Times* ten years after her enlistment, Cathay said that the army surgeon discovered she was a woman, and the men drummed her out. If she had been discovered, her discharge papers made no mention of it, saying only that William Cathay was "incapable of performing the duties of a soldier because of a scrofulous and feeble habit" and that "he was constantly on sick report."

After her discharge, Cathay Williams resumed dressing and acting as a woman and returned to cooking and doing laundry for hire. She found a husband, but instead of supporting her, he ran off with her valuables, cash and horses. She settled at last in Trinidad, Colorado, where she fell ill. Perhaps inspired by the size of her hospital bill, Cathay applied to the U.S. government for a disability pension. She swore out an affidavit that she was the same William Cathay who had served in Company A, Thirty-eighth Infantry, for two years and that the illnesses she had contracted during her service had rendered her incapable of manual labor.

Although the Pension Bureau could have denied her disability on the basis that she had enlisted illegally, it did not, nor did it question that a woman had signed up to serve. Instead, despite the doctor's report that all her toes had been amputated, it denied that she was disabled. As for her chronic illness, her discharge papers (which omitted to mention she was female) state that her feebleness predated her enlistment, so the army would not grant her petition on those grounds either.

Despite her optimistic statement to the *Daily Times* that "I expect to get rich yet," Cathay Williams lived in deep poverty until she died at the age of eighty-two. She did make her mark on history as the first African American woman to serve in the United States Army.

ALBUQUERQUE (ALMOST) GETS NUKED

Albuquerque residents never sit around and share their memories of the day a hydrogen bomb dropped on the city's Southeast Heights. The day in 1957 that the malfunction of a B-36 bomber caused the plane to release its deadly contents passed unremarked at the time. What could have been the nation's worst nuclear tragedy was not widely known until recently, when reporters retrieved declassified information and found out how close central New Mexico came to fiery annihilation.

The bomber's crew of thirteen men was getting ready to land at Albuquerque's Kirtland Air Force Base. They were flying from Texas. Although the documents regarding the cargo are still classified, that model plane was often armed with a ten-megaton hydrogen bomb, many times more powerful than the ones that wiped out Hiroshima and Nagasaki. Although the U.S. Air Force admitted nothing, rumor was rampant that nuclear warheads were being stored in a bunker near the Four Hills of Kirtland.

That particular model of bomber required manual removal of a pin that prevented accidental release of bombs while in flight, but removing the pin was no easy task. The crew member responsible, First Lieutenant Bob Carp, had to stretch awkwardly across the bomb bay, balancing on tiptoe, to twiddle the pin out.

Perhaps the bomber malfunctioned, perhaps turbulence jostled the precariously positioned Carp and caused him to hit something critical or perhaps, as some documents suggest, the release mechanism had been jury-rigged by thoughtless repairmen. Horrified, Carp and his crewmates watched as the doors in the plane's belly tore off under the sudden weight of the warhead and the bomb irretrievably fell out of sight. One man even shouted, "Bombs away!" in a kind of shock.

The plane, freed of the forty-two-thousand-pound bomb, shot upward before the pilot could bring it under control, but an alert radio operator did have the presence of mind to shout a warning to the control tower. Before the men at

the base could react to "We've dropped a hydrogen bomb!" the bomb itself impacted on the sage-covered mesa below.

The bomb and cargo bay doors landed with a crash on an unoccupied area three to four miles south of Kirtland Air Force Base and exploded—and that was all. Fortunately, while the conventional explosives used to trigger the bomb did detonate, the part of the bomb that would cause a nuclear fission reaction had been moved prior to transport.

A single hapless cow grazing on the mesa represents the sole fatality of this nuclear incident. Investigators found cow parts scattered all around the twelve-foot-deep, twenty-five-foot-wide crater left by the impact.

Slight radioactivity was found inside the crater where the bomb had landed but not beyond the lip. The U.S. Air Force buried the site and the documents relating to the investigation but presumably did address the poor design that led to the accident.

Nearly thirty years later, a post–Cold War U.S. government started to let the sun shine on old nuclear weapons information. In response to a 1986 FOIA request, Albuquerque reporters discovered documents reporting the incident. Some materials, like exactly what was being transported and why it was being shipped to Kirtland, remain classified, but enough emerged for the reporters to track down the crew of the B-36—all of whom were still alive—and get their eyewitness account of the story. For the first time, Albuquerque citizens learned how close they had come to being vaporized by our own troops.

In the spring of 1996, archaeologists from the Center for Land Use Interpretation (CLUI) got permission to survey the impact area, which is still owned by the University of New Mexico, and discovered slightly radioactive bomb fragments still scattered around the site. As part of the Peculiar Detonations series of its "Broken Arrow" project, commemorating nuclear weapons mishaps, CLUI erected a marker on the site.

Part VII

PUZZLING PLACES

THE MYSTERY ROCK

One of New Mexico's most compelling archaeological treasures—or one of the most transparent fakes—will never find a home in a museum. Regardless of its authenticity, no one is planning on moving the eighty-ton boulder, called the Los Lunas Decalogue Stone, from Hidden Mountain. It seems to be a two-thousand-year-old inscription in an ancient Paleo-Hebrew alphabet with a sprinkling of Greek listing the Ten Commandments, but like much in New Mexico, what it seems to be may have little to do with what it is.

In translation, it reads:

> *I am Jehovah your God who has taken you out of the land of Egypt, from the house of slaves. There must be no other gods before my face. You must not make any idol. You must not take the name of Jehovah in vain. Remember the Sabbath day and keep it holy. Honor your father and your mother so that your days may be long in the land that Jehovah your God has given to you. You must not murder. You must not commit adultery. You must not steal. You must not give a false witness against your neighbor. You must not desire the wife of your neighbor nor anything that is his.*

What would it have taken for travelers from ancient Sumeria, Israel or Phoenicia to find themselves in

central New Mexico? How did they find themselves with enough leisure to neatly chip away their laws in a handy boulder? What kinds of mishaps and misadventures would not only blow you across the sea but also drive you so far inland?

Certainly, the Phoenicians were a mighty seafaring race and might have even been early converts to Jewish monotheism. But even if they made it to North America, and even if they were somehow inspired to trek inland, Hidden Mountain, a forbidding gray volcanic rock protruding above the seasonal trickle called the Rio Puerco, seems an inauspicious place to stop. It's particularly hard to conceive of what else these people would have been doing, as there is (suspiciously) no material evidence of any ancient Semites camping out here while they patiently carved the commandments.

A couple of thousand years is a long time, so perhaps it's not so odd, but at least one archaeologist dismisses the possibility that the carvers would have left nothing else behind. He suggests possible tongue-in-cheek scenarios for explaining the lack of material culture: the carvers were "a group of obsessive-compulsive neat freak[s]"; they parachuted in; or they had "beamed in from an alternate dimension." The Phoenician script, which is practically identical to the Paleo-Hebrew of the Decalogue Stone, was known in the 1880s, and some paleographers contend that the punctuation is more consistent with a more modern Hebrew.

If they didn't carve it, who did? It's easy to imagine ancient travelers, far from their native lands with no hope of return, carving an inscription to leave one lasting reminder of their presence on earth. Imagining a rugged New Mexico rancher, well versed in classical Phoenician, carving the stone between roping calves is much harder and also lacks historical support. While there were plenty of homesteaders who knew their Bible, no one in Los Lunas tells legends about some brilliant cowboy obsessed with long-dead languages.

Archaeologist and UNM professor Frank Hibben was the first to record the site, after being led to it by a man who discovered it while wandering around as a boy in the 1880s. Hibben, who was unprofessionally eager to find evidence of human antiquity in New Mexico, declared it authentic and enthusiastically described it as thickly covered with lichen and patination. Many suspect the stone was created around the time of its "discovery," when Paleo-Hebrew was fairly well known, and point to Hibben's shaky record of seeing what he wanted to see in the hopes of proving that New Mexico had a longer history than was commonly accepted. As one contemporary told a reporter about Hibben, "Frank had a reputation in Albuquerque for—it would be kind to say—stretching things." When caught in the act of fabricating evidence, Hibben usually blustered his way out, but his obsession cast much of his work in doubt.

Once, scientists might have been able to establish the age of the inscriptions, but earnest visitors have scrubbed the

rock face clean, some with wire brushes, making the script clearer but erasing any clues as to the stone's real age. One geologist guessed its age as between five hundred and two thousand years old, with wiggle room on either end.

Perhaps the authenticity of the Los Lunas Decalogue Stone will never be validated, but true believers couldn't care less. For twenty-five dollars, you can get a permit from the New Mexico State Land Office and hike out to see it yourself and puzzle over what it might mean and who might have taken the time to carve out the letters so carefully for the ages.

What's Below the Mesa?

The ominously dark basalt extrusion of New Mexico's Black Mesa makes a startling contrast to the gently rolling river plains of San Ildefonso Pueblo. Even if it didn't have such a storied past, people would have been inspired to make up legends around this sacred place. Although Black Mesa is off limits to casual tourists, we have a good sense of what's on it. What's under it is a different story.

Tewa legend holds that a giant and his family used to live on top of the mesa and would stride over to the pueblo every day and eat children until the war gods killed the giants. If place names are any judge, the giant also rubbed his penis on a long rock in the area, carving a trough in the center. A large white stone at the edge of the mesa is

said to be what's left of the giant's heart. A dome-shaped formation is called the Giant's Oven, the site of a Native American version of the Hansel and Gretel story in which the giant's evil daughter is burned up instead of the war gods. It seems that regular offerings are still left on a mesa-top altar.

For the people of San Ildefonso, Black Mesa represented their last, best refuge. Only four routes can be ascended to the top, and clear evidence of early fortifications shows that every one of those routes was closely guarded during times of siege, although the young men slipped past the walls at night and carried water from the river back up to the people.

During the Reconquest after the Pueblo Revolt, Governor Don Diego de Vargas attempted to subdue the San Ildefonso people but was stymied three times when the Puebloans retreated to their mesa stronghold. At one point, the Tewa camped out up there for a month before de Vargas gave up in disgust. While they eventually surrendered, the ruins of the village the Puebloans built to withstand the siege show they were ready to stay as long as necessary.

But there might be more about Black Mesa than can be found on the surface. While being interviewed for an oral history project in the 1960s, Santa Clara elders shared some odd information they had about Black Mesa. José Naranjo described a cave on the mesa with a hole in the back that is so deep it seems to go all the way to the bottom of the mesa (judged by how long it takes for dropped rocks to thunk on

the bottom). Wind blows up through the hole, and people leave prayer sticks and offerings in the cave. One man tried to descend on a rope, but the wind was so strong it blew him back up, even when he weighted himself with stones.

Naranjo shared the legend that the cave was another old escape route, through which the Tewa could drop and then escape through a tunnel all the way to Chimayo, about eighteen miles. Over time, the escape route had been filled in with sticks. He went on to add that there was a similar tunnel by San Juan and one in Tesuque. He even claimed to have gone down into one 150 feet under Santa Fe, where he found a table with a turkey shot with an arrow on it and several mummified rattlesnakes, offered as a kind of sacrifice. According to the old man, "There was tunnels going all over the place," but to his eye, most were leading toward Black Mesa.

Naranjo wasn't the only one to speculate about what lies at the heart of Black Mesa. A cave has indeed always existed at this place, and about 1882, a woman in Illinois started having visions about it while in a hypnotic trance. She believed there was great mineral wealth somewhere in the cave and apparently was able to convince a few others, for the five of them showed up, blasted the cave and dug as deeply as they could. After digging about seventy-five feet back and twelve feet down, they gave up and returned to Illinois.

CONFEDERATE NEW MEXICO

The New Mexico legislature first conceived of Arizona, thinking that all the desert lands west to the Colorado River could be designated as a home for the Apache and Navajo, who were causing misery in New Mexico with their incessant raiding. Under this plan, New Mexico would continue to include the settlements on the upper Rio Grande and the Plains, stretching across the well-timbered and watered Colorado Plateau to Hopi and on to the Colorado River. The idea of Arizona spiraled out of their control until New Mexicans faced an invasion from a place called "Arizona."

Anglos who had settled in the borderlands near promising mineral deposits had a different idea about Arizona than the legislature. These settlers and prospectors felt that territorial status would finally give them enough of a military presence and infrastructure so they could live where they wanted and get rich exploiting the mines. A group of men in Tucson had floated a proposal before Congress in 1860, but bitter partisan deadlock over the admission of new states doomed the proposal before the ink was dry. They did accept the division suggested by the New Mexico legislature but claimed a somewhat larger portion.

With the start of the Civil War, southern New Mexicans felt the impact immediately. The United States suspended the Butterfield mail service, cutting the settlers off from their primary link to the larger nation. The Confederate government indicated that it would be amenable to a new

territory, and so the disgruntled citizens made their choice. Perhaps what they wanted most was their mail, but what they got was a war.

Confederate Arizona got its official start in Mesilla, New Mexico, the new territorial capital. The newly formed government issued a proclamation that enumerated its complaints against the U.S. government. Primary among these were the inadequate protection from raiding and the loss of the mail route. Confederate Arizona, like earlier incarnations of Arizona territories, reached all the way west to what is now Yuma. A phrase in the proclamation—"The citizens residing in the western portion of this Territory are invited to join us"—reveals how realistic the framers of this new territory were about the chances that people beyond Tucson would even hear about this new territory, much less enthusiastically join in the cause.

The Civil War caused a rift among the military stationed in New Mexico. West Point–educated General Henry Hopkins Sibley had firmly aligned himself with the secessionist cause and was inspired by the Mesillans. He saw a chance to use the bases in what was now Confederate territory to launch an invasion of New Mexico and believed that the New Mexicans, so recently occupied by the United States, would enthusiastically support secession. From there, he imagined he would gloriously push through to California and open up the Pacific ports to the Confederacy.

Sibley began to get his men in place, and all his plans hinged on the existence of the seceded lands of Arizona.

He wrote to the commander of his advance brigade: "On arriving at El Paso (should you do so before the arrival of the General) you are authorized to assume the Command of all the forces of the Confederate States within the district of country known as Arizona and also at Fort Bliss or between there and the frontier of Arizona." He must have been familiar with the Mesilla proclamation, for he also advised "that while en route as well as after your arrival in Arizona you should furnish to all Citizens of the Confederate States and of that Territory and their property, such protection as you can against the hostile attacks and depredations of the Indians."

Lieutenant Colonel John R. Baylor successfully moved his Texas Mountain Rifles into Mesilla and seized Fort Fillmore and Fort Stanton. Flush with success, he proclaimed the establishment of Arizona in the Mesilla plaza: "The social and political condition of Arizona being little short of general anarchy, and the people being literally destitute of law, order, and protection, the said Territory, from the date hereof, is hereby declared temporarily organized as a military government until such time as Congress may otherwise provide."

Thanks to Baylor, Sibley's troops were able to use Arizona as a base for invasion. Although the Texas brigade pushed through much of New Mexico, Sibley underestimated how New Mexicans would react to yet another invasion from Texas. Without materiel support, his forces soon ran out of food, clothes and ammunition and were ignominiously

forced to retreat back to Texas. Regardless of what a few people down in Mesilla thought, most New Mexicans were not willing to secede.

Sibley tried to put the best face he could on his defeat when reporting the failure of his western campaign. Yet once back in Texas, he wrote bitterly, "Except for its political geographical position, the Territory of New Mexico is not worth a quarter of the blood and treasure expended in its conquest." Probably unknowingly, he echoed the regretful missives of generations of Spanish and Mexican governors and military commanders.

In 1863, the United States government finally created Arizona as we know it now, cutting New Mexico in half along the 109th meridian. The Confederate Territory of Arizona was never more than an idea of a few people and played little role in the fate of the Confederacy, but it did eventually get the southern mail service route restored.

THE SHIFTING SOUTHERN BORDER

In 1848, when Mexico surrendered its northern territories, the next step was figuring out what exactly the United States was acquiring. Although the boundary description in the treaty seemed clear to the signatories, it turned out not to be. The choice of the Rio Grande for a border also caused international disputes. In all, establishing New Mexico's southern border took nearly a century.

The negotiations of the Treaty of Guadalupe Hidalgo were undertaken in good faith but with a bad map. John Disturnell's 1846 *Mapa de los Estados Unidos de Méjico* was a popular map that year, even though Disturnell had used someone else's plates with minor additions. It looked great, with lots of colors and detail and a nice clear line above "Forte Paso del Norte" (El Paso), where Nuevo Méjico started. That line seemed fair to everyone at Guadalupe Hidalgo, and so it was agreed that "the southern and western limits of New Mexico, mentioned in the article, are those laid down in the map entitled 'Map of the United Mexican States.'" But Disturnell's erroneous map showed El Paso just a few minutes below the thirty-second parallel, while in reality it is thirty minutes below.

When this problem of the missing twenty-five to thirty degrees of latitude arose, no one was quite sure where the boundary was supposed to go. Still working in the spirit of conciliatory diplomacy, the United States and Mexico formed an International Boundary Commission. The American commissioner was John Russell Bartlett, who saw the position as an excellent chance to have some frontier adventures. His popular memoirs of this period detail desperadoes and lovely señoras, adventures and fascinating indigenous culture, but not so much about surveying.

Instead of undertaking the toilsome work of surveying in the pitiless Chihuahuan desert, Bartlett came to something of a gentleman's agreement with the Mexican commissioner, General Condé. They agreed that the

boundary would follow the latitude lines on Disturnell's map, adjusted to correct astronomical observations, rather than the description given in the treaty, in which the border is supposed to go straight west from where "the Rio Grande…strikes the southern boundary of New Mexico… along the whole southern boundary of New Mexico, which runs north of the town called Paso." On top of this, while they agreed to set the boundary at thirty-two degrees, twenty-two minutes north, they actually set the line at thirty-two degrees, twenty-three minutes, giving up another swath of land all the way to the Pacific.

The surveyors with Bartlett, such as A.B. Gray, protested this decision vociferously. In a report to Congress, Gray argued that the commission meant the boundary of New Mexico to be approximately where it was on Disturnell's map, just north of El Paso, rather than all the way north by Mesilla, as (the perhaps vengeful) Condé had put it. He painstakingly drafted a map showing the difference in how much land the United States stood to lose under this agreement. Since he felt his reputation was at stake, he submitted a heated polemic condemning Bartlett with the map: "Mr. Bartlett refused to be guided by the actual position of the town of Paso, an object specifically mentioned in the treaty, and consented to be governed by a reference to the imaginary position of a parallel, which was evidently located, as far as the region referred to is concerned, without the aid of astronomical observations."

Congress heard the surveyors' protests and promised to take them under consideration. Before it got around to considering anything, the United States purchased from Mexico much of the land it could have had by treaty. The issue was moot whether the Condé-Bartlett line was accurate or even whether the line was where it was supposed to be. The Gadsden Purchase, as well as settlements made with Texas in 1850, required another survey.

A second commission was convened in 1855. This time, the American surveyor, the redoubtable William Emory, got his way. Working with his Mexican counterpart, Jose Salazar y Larregui, Emory first established the position of International Boundary Marker No. 1, where the parallel of thirty-one degrees, forty-seven minutes strikes the Rio Grande, a full twenty-five degrees south of the previous border. From there, they worked all the way to California, building small stone monuments at their survey points.

Yet the saga of where New Mexico's southern boundary lay was not over. When the Treaty of Guadalupe Hidalgo was signed, the Rio Grande seemed like a fairly permanent border, but in fact, the river restlessly shifted its boundaries in those days. If both sides are in the same nation, this is not a problem, but in 1889, many Mexican and American farmers noticed that the river was picking up soil from their properties and depositing it on the other side of the banks. This caused another round of headaches for cartographers and scorching desert marches for surveyors.

Floods in the early twentieth century again caused farmers to wake up and find their fields in another country. The dam-building projects of the New Deal caused yet another round of revisions on the maps, until all the boundary issues were settled for good.

IMAGINED TOWNS OF THE SOUTHERN PACIFIC

Old railroad maps from the Southern Pacific's Sunset Route from New Orleans to San Francisco show a solid line of towns punctuated by the three cities of El Paso, Deming and Lordsburg. As any modern traveler knows, the corridor between El Paso, Deming and Lordsburg is mostly punctuated by creosote bush, ragged rock outcrops and tumbleweeds. Even the most experienced New Mexico traveler may scratch his head when asked about Wilna, Tunis, Cambray or Separ. Did these towns disappear, or were they ever really towns at all?

The story goes back to the land grants issued by the federal government to the railroads in order to help defray construction of new rail lines. Southern Pacific's Sunset Route was completed in 1883, and the trains ran from the Gulf of Mexico to San Francisco Bay. The bosses at Southern Pacific needed to start making big money off their lines and set to work selling their real estate with a will. Southern Pacific was granted as much as ten square miles of land, including mineral rights, for every mile of track it

laid, in alternating square-mile sections. The construction of the railroad itself had brought enough economic activity to kick-start the towns of Lordsburg and Deming, but there were no other permanent settlements. So the railroad marked out a regular series of towns where the train would stop and through which all roads would pass someday.

Southern Pacific had the trains stopping at these locations, and some places even had buildings, but it still needed to get people disembarking at Pyramid, Lisbon and Afton. *Sunset Magazine*, the Southern Pacific's in-house organ, published (and continues to publish) glowing articles about the easy living of the Southwest, the mild climate, the possibilities for agriculture, the untapped potential of the land and the varied economic opportunities of the region. Most of the articles focused on lands along the California portion of the route, but a few articles reveal the tactics used to sell land in New Mexico.

For example, an article promoting alfalfa farming in the Mimbres Valley does not dwell on the stony, desert conditions of the bottomlands around Deming; instead, it points out how building an irrigation system doubles or quadruples the value of the land. Farming in an area of permanent drought is no disadvantage but a blessing. According to the booster who wrote this article, "The average annual rainfall in the valley is only eight inches, so you can see how rarely rain interferes with harvesting." Even in the days of a rain-follows-the-plow Pollyanna approach to western settlement, such heedless optimism went little heeded.

Watering the crops was less of a concern to the average newspaper reader than getting massacred by the Chiricahua Apaches, who were reaching the peak of their war with the Americans as the railroad was being built. Those whose gold fever overcame their good sense and led them to settle in this traditional Apachean territory were on constant, hysterical alert against the raiders. The end of the wars came within years of the Sunset Route's establishment, but southern New Mexico's reputation for being a lawless, cruel country remained.

The Southern Pacific kept trying to sell this region to its readers. In 1900, ads trumpet "surprisingly low prices" on lands in New Mexico; ads a few years later promoted "vast tracts suitable for colonization," precious "for their mere value for grazing." By 1913, it was clear the railroad would be happy even to sell land around Deming or "the metropolis of this rich valley," as *Sunset Magazine* editors would have it, where "folks are gaining wealth and health." By 2011, the population of Deming had grown to over fourteen thousand hardy souls, still falling short of the ideal of a metropolis.

A few communities showed a feeble spark for a while. A modest silver deposit was discovered near the water station of Pyramid, east of Lordsburg, and the settlement grew around it for about a decade; then Pyramid died. Three abandoned buildings and an operating curio shop in Separ testify that people did, and still do, live there, though perhaps not in the numbers commonly associated

with a town. The population of Gage once reached 102 people, and it had its own ticket agent in 1900 but now exists only as a truck stop. Wilna is likewise reduced to a single business, the Continental Divide diner. Aden supported a post office until 1924, but nothing remains now except a sign. Hudson's post office also closed down in the mid-1920s. Afton is recalled as the name of a road and is still listed as a populated place east of Mesilla, at the edge of a field of volcanoes, but no longer has a post office. Cambray never seemed to have much development beyond a water well, although it might have grown to village size around 1892.

Government Land Office records show that the Southern Pacific Company remains the major landholder in what are now lonely intersections on the country roads of New Mexico, although recent mineral booms have allowed Southern Pacific to sell more of its underground mineral rights. Despite the company's best efforts for over a century, evidently saying a place is a town isn't enough to make it so. Perhaps the railroad towns once optimistically laid out on tourist maps did become towns at one point, but the life of each of these imagined places was so tenuous that they melted back into the ground before they were even noticed. Now, they are barely remembered.

THE FORTS THAT NEVER WERE

In 1860, the U.S. Army was busy establishing supply depots and military reservations across New Mexico and the West, but no general in Washington, D.C., ever imagined how human stubbornness would foil the plans for one fort in particular. The commanders in the East, unfamiliar with New Mexico's land and people, applied the best possible theory. They carefully measured off forts at reasonable intervals along trails and waterways in order to establish a fail-proof chain of supplies and troops. General Orders No. 6, issued in March of that year, commanded the establishment of a six-company post at some suitable location on or near the Canadian River, to be called Fort Butler.

Theory met reality in the form of the commanders of Fort Union, located along the Santa Fe Trail, who liked things the way they were. Fort Union was the major supply depot for all of New Mexico, and the commanding officers were not about to cede the power that gave them. Pressure to start building came from the New Mexico press, which heralded the promise of new settlement along the Canadian River. The Canadian watershed, and much of the eastern Plains, was rendered all but uninhabitable by the raiding Kiowa and Comanche, who were becoming increasingly desperate and angry as the bison slowly disappeared and their homeland was plowed under for settlers' farms.

Although designs were submitted and materials for the fort were allocated, the men at Fort Union dragged their feet on getting started, resorting to blaming the New Mexico weather: too hot, too windy, too cold, too muddy, too dry, too everything. Presumably, the commanding officer sent some assurances back east because in time Fort Butler was garrisoned—again, in theory. Whether the troops ever showed up for duty is questionable. The Civil War erupted shortly thereafter, in the spring of 1861, and the issue of Fort Butler's fate paled into insignificance for the U.S. Army.

Even in New Mexico, the question of Fort Butler was dropped. Some of the citizens in southern New Mexico territory had seceded as the Confederate Territory of Arizona, and Texan Confederates were using those bases to launch an attack. As the troops at Fort Union scrambled to stop the invasion, Fort Butler was completely forgotten, never to be resurrected, even as an idea.

After the war had been fought to its bitter end, and the difficult business of Reconstruction had been undertaken, the U.S. Army once again turned its sights west. Noting Fort Butler on the maps, alone in the middle of the Plains, the thoughtful officers in D.C. had the bright idea of establishing another fort along the Canadian River to replace the no doubt worn and struggling Fort Butler, whose men (the army commanders imagined) had been toughing it out alone in hostile territory for nine years. The land surrounding the proposed Fort Bascom was formally

withdrawn as a military reservation, and Fort Butler was scheduled to be decommissioned.

Whether this series of mishaps and misunderstanding would have continued until a line of imaginary forts stretched along the Canadian from its headwaters on down is unknown. The withdrawal of lands around Fort Bascom sent up flags among land grant lawyers researching the Pablo Montoya land grant, one of the last granted by the king of Spain before the Mexican Revolution severed ties with the fatherland. In May 1872, the deputy surveyor finished his survey and noted that the Montoya grant included the withdrawal for Fort Bascom, as well as the proposed site for Fort Butler, which had never been properly established as a military reservation.

At the same time, the army discovered that it was going to be tricky to decommission Fort Butler, since it had never been built. This discovery set off an investigation that returned the shocking results that Fort Bascom had never been built either. One can imagine the heads exploding along the Potomac. Predictably, the discovery set off a decade of gruesome bureaucratic wrangling. How do you decommission a fort that was never commissioned? What forms can you file to return land that was never taken? The secretary of the interior tried by submitting letters to the War Department promising that he was "not aware that the reserve was ever used as such, and [is] informed that there is no prospective need for it." Not being able to agree on how to handle such a case, the departments had to refer

the matter to Congress, requiring another round of memos trying to justify undoing something that was never done.

Congress took little interest in the matter. New Mexico's surveyor general entered a suit to open those lands of the Montoya land grant for homesteading. Finally, the matter was decided by the acting commissioner of the surveyor general in response to this suit: he simply directed the surveyor sent to survey the land to omit the boundaries of the hypothetical withdrawals. Such an end was possibly the only way to erase Fort Butler and Fort Bascom, which, after all, had never existed anywhere besides on a map.

GHOSTS OF THE URRACA MESA

The land for the Philmont Scout Ranch near Cimarron, New Mexico, was donated to the Boy Scouts of America by Waite Phillips, founder of Phillips Petroleum. The donation included Urraca Mesa, around which swirl more stories of the supernatural than any other place in New Mexico. Urraca is a Spanish name meaning magpie, which may be an indication that the place's reputation for ill omen dated back before the Boy Scouts arrived, cooking up scary stories along with their signature Dutch oven stews.

Around flickering campfires, generations of Boy Scouts have speculated about whether Urraca is really a gateway to the underworld, guarded by a shamanic spirit that sometimes appears as a floating blue light. Counselors

explain to the boys that there were four cat totems at the edges of the mesa designed to work as a lock keeping the demons securely in the underworld. The spirit of the mesa guards the totems, whose destruction will surely mark the end of the world, but despite its vigilance, two have already fallen. Alumni of the Philmont Scout Ranch can also relate other hair-raising tales about the place: a young scout in an old-fashioned costume who joins hiking trips but disappears as the troop leaves the mesa; counselors who meet tragic ends on the mesa and whose bodies are sometimes found scorched or charred; photographs that show strange lights and blurs when developed; and an invisible, but audible, herd of mustangs.

Some of the tragic stories of Urraca Mesa, as well as many eerie phenomena, are verifiable. Certainly, the area has a tragic history that started long before the Boy Scouts acquired the land. During the turbulent decades of the American occupation, this area had the reputation of being a sort of no-man's land, where bandits; Texans; roving bands of Comanche, Kiowa and Utes; cowboys; miners; and American soldiers clashed over and over again, usually with fatal results. The nearby town of Cimarron means "wild," or "unbroken," in reference to the people who were drawn to this lawless corner of the world.

The millionaire Waite Phillips had originally acquired Urraca Mesa for pennies on the dollar during a foreclosure sale. Twenty-six-year-old Lebanese immigrant Cory Elias migrated here and received a homestead in 1909. In

subsequent years, he acquired more land, fathered three children in eight years and then died in a tragic automobile accident. His widow, Dovie, could not pay the taxes due on the sprawling ranch without a man to work it, and before long she and her small children were driven from their land to fend for themselves or scatter to the winds.

Homesteading was preceded by careful surveys of all the lands of New Mexico, and many people studying topographic maps have been struck by how much the northern part of the mesa resembles a human skull. This resemblance has also fueled speculation for at least a century as to the spooky or demonic nature of Urraca Mesa. Boy Scout legend has it that there is a grave behind the eye of the skull of a powerful Native American medicine man who may appear to help frightened hikers (camping on the mesa is prohibited except in exceptional circumstances).

How the topographers managed to survey the mesa so accurately is a story lost to history. Urraca Mesa has significant lodestone deposits, which have the twin effects of scrambling compass needles and attracting more lightning strikes than anywhere else in New Mexico. Rather than suspecting supernatural forces, it's more probable that the hapless lost counselors were victims of the geologic forces of the mesa. The powerful magnetism of the area may also be responsible for the anomalies on developed film. The Boy Scouts are strangely silent on whether the same phenomena occur with digital cameras.

Glossary

alcalde mayor: Head official of the New Mexico town council.

Apachería: The homeland of the Apaches, including much of southern New Mexico and Arizona.

atole: A thick, corn-based hot drink.

bailes: Fandangos and balls were popular social events in New Mexico for centuries and were a feature of practically every fiesta or celebration.

bando: A pronouncement read in every village or town plaza.

barrio: Neighborhood.

cedula: A mandate issued by the viceroy of New Spain in Mexico City.

Chihenne: "Red Paint" Apaches, also known as Copper Mine, Mimbres or Warm Springs Apaches, who lived in and around the Gila Mountains. During the Indian Wars, this band was led by Victorio and then Nana.

Cortes: The Cádiz Cortes was a legislative body that convened during the Napoleonic Wars and included representatives from many Spanish colonies. The Cortes drafted a constitution in 1812, but when its "Desired One," Ferdinand VII, returned to the throne in 1814, he refused to recognize it, spurring the separation of Mexico (and most other colonies) from Spain.

curandera/curandero, curandismo: A traditional herbal healer, the *curendera* (most were women) could be native or Hispanic, but often *curandismo* was a rural community's only available medical care. Many *curanderas* were also *parteras*. Some were accused of witchcraft.

custos: Prelate or custodian The *custos* in New Mexico had authority over all the missions and in early days had the power of the Holy Office of the Inquisition as an enforcement tool.

diligencia: An investigation, usually into the families, relationships and characters of two people who intend to marry but sometimes conducted for other purposes.

Diné: The Navajo name for the Navajo, meaning "People."

Dinetah: The homeland of the Navajo, commensurate with their traditional place of worship. The boundaries, which correspond to the four sacred colors and directions, are Blanca Peak in Colorado, Mount Taylor in New Mexico, the San Francisco Peaks in Arizona and Hesperus Peak in Colorado.

El Camino Real de Tierra Adentro: The royal road to the Interior Province. Royal roads connected two

Spanish capitals, in this case Santa Fe and Mexico City. Americans called this road the Chihuahuan Trail, and today Interstate 25 roughly traces the route from Santa Fe to El Paso.

encomienda, encomendero: The *encomienda* were taxes levied on the Pueblos and paid in goods or labor to the *encomendero*, at the discretion of the governor. Some *encomiendas* were traded or used as assets.

estancia, hacienda, rancho: New Mexicans were rich in land and, depending on their resources, developed it more or less. An *estancia* was an estate that often served as a production center for manufacturing, processing, warehousing and shipping local goods. The *hacienda* is the residence on an *estancia*, while a *rancho* is more of a small, single-family farm.

fetish: An object of ritual significance, constructed to give the bearer some power.

genízaro: Acculturated Indians from many tribes, captured or bought while young and raised as Christians in Spanish households. The *genízaro* were not quite slaves and most were given their freedom eventually, although often so late in life that they were unable to make a living for themselves. While the Spanish felt it was a great kindness to secure the children's place in heaven by raising them Christian, *genízaros* were often conflicted and resentful. During the eighteenth century, many *genízaros* were granted their own community charters, mostly on the frontiers in places like Abiquiu and Tomé, where they

served as a buffer to protect "pure" Spanish communities, such as Santa Cruz and Santa Fe. *Genízaros* were formally recognized for their contributions as indigenous people by the New Mexico legislature in 2007.

Hwéeldi: Navajo term for the reservation at Fort Sumner, also known as Bosque Redondo. It can be translated as "the place of suffering," or simply "suffering."

Keresan: The language spoken at Cochiti, San Felipe, Santa Ana and Santo Domingo (eastern Keres), as well as Acoma and Laguna (western Keres).

kiva: Kivas are a hallmark of Pueblo architecture and serve as social and ritual chambers for the male groups. They are often round underground chambers reached by ladders.

médicas: Female doctors.

mestizo: Having mixed Spanish and native parentage. The colonial Spanish were very conscious of racially based class distinctions, starting with "pure" Spanish and including a range of classifications based on other ethnic heritages or mixes.

Naakai: Mexican or Spanish, in the Navajo language.

paraje: An area used frequently as a camping stop on the long trail between Chihuahua and Santa Fe, mostly characterized by adequate access to forage, water and firewood.

partera: Midwife.

presidio: A fort.

procurador: The king of Spain funded the New Mexico mission supply out of his own pocket for nearly two hundred

years. The *procurador* bought supplies for all the missions, which amounted to a considerable amount of trade every year and made the office of *procurador* an important position.

punche: A native New Mexican weed that many smoked as a substitute for tobacco, despite its harshness and offensive pungency.

rancherías: Comanche villages.

residencia: Each arriving official was required to conduct an audit and trial of his predecessor, a task that occupied months and even years of time. *Residencias* often caused great inconvenience and expensive penalties for the retiree.

torreons: Fortified watchtowers, sometimes built as part of the enclosing wall of a *hacienda*.

viceroy: The viceroy of New Spain served as administrator in the king's stead. He had authority over Spanish colonies in South America and Central America, Mexico and New Mexico.

Illustration Credits

Cover
Detail from "Morning on the Santa Fe Plaza." From
Ernest Ingersoll. "La Villa Real de Santa Fe." *Harper's New
Monthly Magazine* 60, no. 359 (April 1880): 667–82.

Frontispiece
1883 Map of New Mexico. Detail from *United States of North
America, and part of Canada*, western sheet. From *Lett's Popular
Atlas, 1883*. Image No. 5371116 © Rumsey Collection.

Domestic Strife
Spies, Smugglers and Traitors and
Strange Alliances
Father Ignacio, Doña Tules (Gertrudis Barcelo) and Doña
Tules' gambling saloon. From G.D. Brewerton. "Incidents
of Travel in New Mexico." *Harper's New Monthly Magazine*
8, no. 47 (April 1854): 577–96.

POISONOUS POLITICS
The Palace of the Governors, circa 1885. From
Governor William Gillet Ritch. *Aztlan: The History,
Resources, and Attractions of New Mexico*. 6th ed. Boston: D.
Lothrop & Co., 1885.

WITCHES, PRIESTS AND MYSTICS
Penitentes. From Brige Harrison. "Española and Its
Environs." *Harper's New Monthly Magazine* 70, no. 420 (May
1885): 825–36.

LIFE DURING WARTIME
U.S. Army Fort. From William H. Rideing. "Wheeler
Expedition in Southern Colorado." *Harper's New Monthly
Magazine* 52, no. 312 (May 1876): 793–807.

PUZZLING PLACES and
BACK COVER
Skeleton and tree riddled with arrows. From George D.
Brewerton. "Ride with Kit Carson." *Harper's New Monthly
Magazine* 7, no. 39 (August 1853): 306–35.

About the Author

Having lived half a lifetime in New Mexico, Ellen Dornan has fallen in love with the rich cultural and natural heritage of the "Land of Enchantment," particularly the legions of scoundrels, misfits and visionaries that make New Mexican history so fun. As a cultural resources interpreter specializing in new media, she has explored the history and prehistory of the state through creating interactive maps and simulations, including the Centennial Online Atlas of Historic New Mexico Maps. She also serves as a history website judge in statewide National History Day competitions.

Visit us at WWW.HISTORYPRESS.NET